IMAGES
of America

SPANAWAY

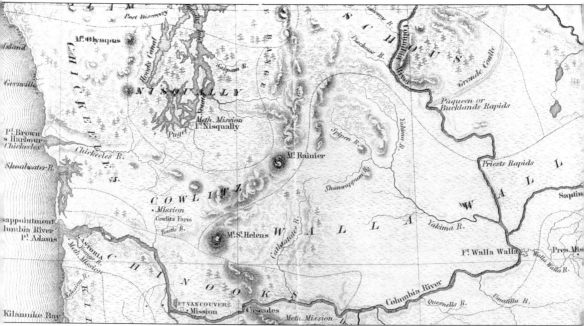

In the vast Oregon territory, Spanaway is a pinprick just below the fingers of Puget Sound and 12 miles southeast of the Hudson Bay Company's Fort Nisqually. This map segment shows the Nisqually Plains tribes. The Native Americans, the Hudson Bay Company, and the geography of this region played key roles in Spanaway's history. This map of Oregon and upper California was drawn by Charles Preuss in 1848. (National Archives and Records Administration.)

ON THE COVER: In 1946, the Spanaway Barber Shop, Spanaway Refrigeration, Art's Shoe Repair, Pearl's Beauty Shop, and the Bargain Basket (not shown) were located in this building on National Park Highway between Seventh and Eighth Streets. In front of their businesses, from left to right, are Bill Mayo, O.M. Johnson, Pearl Armon, Art Linton, and Orville ? (Linton's employee). (Myron Kreidler.)

IMAGES
of America

SPANAWAY

Jean Sensel

ARCADIA
PUBLISHING

Published by Arcadia Publishing
Charleston, South Carolina

Printed in the United States of America

Library of Congress Control Number: 2013948674

For all general information, please contact Arcadia Publishing:
Telephone 843-853-2070
Fax 843-853-0044
E-mail sales@arcadiapublishing.com
For customer service and orders:
Toll-Free 1-888-313-2665

Visit us on the Internet at www.arcadiapublishing.com

"The perfect historian is he in whose work the
character and spirit of an age is exhibited in miniature."
—Thomas Babington MaCaulay (1800–1859)

CONTENTS

ACKNOWLEDGMENTS

Diarists, journalists, photographers, historians, family genealogists, and archivists record and preserve what at the time may seem mundane—even trivial—to their contemporaries. Yet, it is their diligent work that brings alive the people and events that define our "today." Images of America: *Spanaway* is merely a summary of their work, and to them I give all credit. Many are listed, with gratitude, in the bibliography. Dorothy Thompson Winston's 1976 seminal work *Early Spanaway* inspired my research. Owning for a time the historic Exchange Tavern brought Spanaway history to life. I credit Winston and the Exchange with setting me on this journey.

Generous with their help were Julia Park, former Pierce County historian; Joyce Werlink, Washington State History Research Center; Synthia Santos, Fort Lewis Museum; Tija Iles, Lakewood Pierce County Library; Bill Rhind, Fort Nisqually Living History Museum; Carol Neufeld-Stout, Fort Steilacoom Museum; Melissa McGinnis, Metro Parks Tacoma; Megan Moholt, Weyerhaeuser Company; Kerstin Ringdahl, Pacific Lutheran University; and especially Jody Gripp, Tacoma Public Library. Arcadia Publishing editor Rebecca Coffey deserves much credit for her patient guidance through the Arcadia process.

The many early pioneer descendants who opened their family albums and shared local lore have my deep appreciation. Their names appear in the credit lines. Bless you, Bonnie Eslinger and Shirley Zlock, for locating important contributors and materials. The Kreidler family deserves special mention for providing Myron B. Kreidler's 1946 photographs of Spanaway—record of an otherwise lost decade. Thank you, Spanaway Historical Society, for sharing your photographic treasures. Joni Sensel, corporate history and children's author and daughter extraordinaire, gave essential assistance and advice as my preliminary editor. Hubby Irv deserves a heartfelt thank you for his patience while I was "absent in place," buried in research and writing.

Throughout the book, images not individually credited are from the author's personal collection. Abbreviations that appear in the courtesy lines correspond as follows:

 Cathy (Creso) Conner and the Creso family (CCC)
 Hudson Bay Company Archives, Manitoba, Ontario HBCA
 Spanaway Historical Society (SHS)
 Stan R. Lee (SRL)
 Tacoma Public Library Northwest Room (TPL)
 University of Washington Libraries, Special Collections (UWL-SC)
 Washington State Archives (WSA)
 Washington State Historical Society (WSHS)

Images of America: *Spanaway* is a nonprofit project of the *Celebrate!*Spanaway Committee.

INTRODUCTION

Puget's Sound forks into land lying between the towering Olympic Mountains and the volcanic giants of the Cascade Range. On a broad plain south of the sound, local tribes of the northwest coast's Salish-speaking people periodically set wildfires to prevent Douglas fir from encroaching and destroying the grasslands where they pastured their horses and hunted deer, elk, and small game. They are the Squalli-absch (Nisqually), "people of the river, people of the grass;" the S'Puyalupubsh (Puyallup), "generous and welcoming to all people;" and the Shilacum (Steilacoom), "people of the Indian pink [flower] area." They shared the bounty of the rivers and creeks that run like veins between the prairie's spirit-inhabited lakes and marshes and the waters of the sound. Well-traveled north–south and east–west trails crossed at a spring-fed lake called Spa'nu-we (dug roots), meaning a place to gather edible camas and wapato roots. From the east, a sacred, deceptively tranquil volcanic mountain, Tu'qo-bu (Tacoma), watched over all.

Russia, Spain, Britain, and the United States sent explorers and trappers into this region. Only the British Hudson Bay Company established a presence through its fur-trading forts. One of these forts was Fort Nisqually, which was located at Sequalichew Lake on the shore of the easternmost finger of Puget's Sound (some 12 miles west of Spa'nu-we).

Hudson Bay Company traders found that relying on provisioning ships or the local tribes to provide food meant near starvation. They formed a subsidiary, the Puget Sound Agricultural Company, to raise cattle, sheep, horses, grains, and vegetables. One of the company's outlying farms, Spanueh Station, ran east from the shore of Spa'nu-we Lake.

In this era, both the British and American governments encouraged western settlement in an attempt to gain a stronger claim to the land—the United States won. American settlers, drawn by the promise of free acreage, found the agricultural company's farms were on the best prairie land, largely free of trees and with abundant water. So, early settlers staked their claims on land the British company considered its own, including Spanueh Station. The "Bostons," the local tribes' term for American citizens, spelled it Spanaway. A cattle ranch gave birth to the town.

Eventually, the surge of American homesteaders forced the end of British possession of most of the Oregon Territory. The United States paid the British government $450,000 in gold coins for its Hudson Bay Company and gave the privately held Puget Sound Agricultural Company $200,000 for its farms and stock. Moneyed interests in the East wanted access to the riches of the New West and built railroads to the Pacific with spur lines to tap the forests, mines, and fields. With flamboyant prose, they heavily advertised this land of milk and honey. Western migration meant passenger fares in their pockets and guaranteed freight fees for goods their trains would carry from the East to this new market. One of the railroad magnates was Philadelphian Charles B. Wright, president of the Northern Pacific Railway. Wright was a generous benefactor to the growing town of Tacoma, located on Puget Sound (the possessive lost to a mapmaker's error).

Many settlers arriving in Tacoma by train moved up along the Puyallup River that emptied into the sound at Tacoma. Others found their way 10 miles down the more difficult north–south

Native American trail and settled around Spanaway Lake. Wright, who saw Spanaway's lake and streams merely as resources to exploit, took Spanaway farmers' land and water for his favored city, one he loved, as historian Murray Morgan put it in his 1981 book *Puget's Sound*, "perhaps as he might have loved a prize milch cow."

Wright had perhaps the most lasting and (as it turned out) unintended beneficial impact for the beleaguered citizens of Spanaway. One of Wright's Northern Pacific subsidiaries, the Lake Park Land, Railway, and Improvement Company, ran a line to Spanaway Lake when it decided a resort on the eastern shore would be a good draw for land sales and provide an ongoing cash flow from Tacoma day-trippers. That decision was made to ensure remote investors' steady income, unlike the onetime inflow from a land sale, and proved a boon that would forever define Spanaway's character. Its lake became a lasting recreation destination that brought custom to Spanaway businesses and employment for its citizens. The designation of majestic Mount Tacoma as the Mount Rainier National Park (inexplicably named for a British admiral who never set foot in this country) brought tourists from around the world to tarry awhile in Spanaway on their way to the mountain.

In her 1931 account *The Ninety-First at Camp Lewis*, Alice Palmer Henderson noted, "From Washington to Washington is an even greater distance politically than physically." The distance from Tacoma to Spanaway, politically, proved greater than between the two Washingtons. Tacoma businessmen had long proposed a military camp on the prairie south of Tacoma to bring in government dollars. A delegation of businessmen happily traipsed to the other Washington to proffer land they did not own as a gift to the military. The federal government liked the idea, and hundreds of homesteads, entire towns, and most of the Nisqually tribal lands west and south of Spanaway Lake were displaced in a traumatic 142-square-mile giveaway. Still, the military presence also brought economic prosperity to the remaining sectors of Spanaway, as well as to Tacoma and the surrounding area.

Spanaway Lake's park bounced from owner to owner—all of whom wanted to profit from it, none of whom wanted to pay for it, and some of whom wanted to chop it up and sell it off—until visionaries, like Pierce County commissioner Harry Sprinker, secured funds to develop the park and firmly establish it as a regional treasure. Even then, Spanaway citizens donated their time and personal treasures to keep Spanaway Park and its adjacent Sprinker Center as a recreation mecca that offered almost every sport and outdoor activity imaginable. On a few occasions, citizens from distant counties have joined Spanaway residents to protect the park and the town from crass political decisions.

In 1950, a Washington State official, considering the state's takeover of Spanaway Park, claimed to be "highly impressed by the strategic location of the Spanaway area and its potential." Remote politics still buffet Spanaway, and what others consider progress has reached out to challenge the town. Gifted with Spa'nu-we Lake from its guardian, the "mother of waters" Tu'qo-bu, Spanaway's ever-vigilant citizens rise to the challenge.

One

SPANUEH STATION

In 1840, the British Hudson Bay Company founded its subsidiary, the Puget's Sound Agricultural Company, for two purposes: Fort Nisqually needed to feed its growing number of employees, and, according to its charter, the Hudson Bay Company wanted to strengthen England's claim to the territory "through the establishment of farms and the settlement of some of our retired officers and servants as agriculturalists."

Among the outlying farms was Spanueh Station. The Spanueh farm surrounded the shores of a lake about 12 miles southeast of the fort. The company assigned a young employee, Scotsman John Montgomery who had arrived in the territory in 1838, to manage Spanueh Station.

Montgomery had four children—Alex, David, John, and Anna—by two different Nisqually tribe wives. Montgomery's family ties with the local tribes, his relationship with other Hudson Bay Company settlers, and the location of Spanueh Station and his homestead gave him a pivotal role in Spanaway's development.

Montgomery's son Alex worked for the Hudson Bay Company for a few years, then he disappeared. David may have died in the 1853 smallpox epidemic with Montgomery's first wife. Anna married a man Montgomery disapproved of. That proved to be well founded; Smith abandoned Annie, who died not long after. Montgomery's ne'er-do-well son John fled the territory to avoid being arrested. Montgomery's last wife, Elizabeth, remarried after he died in 1885 and moved away. No one was left to tell the story of Spanueh and John Montgomery.

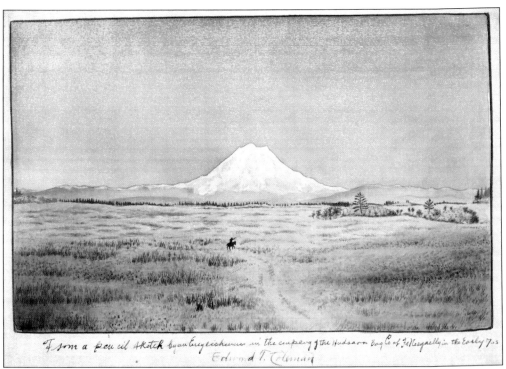

From a pencil Sketch by an Englishman in the employ of the Hudson Bay Co. of Ft Nesquelly in the Early 7.s
Edmund T. Coleman

A Fort Nisqually journal entry from June 1, 1833, describes the grass on the Nisqually Plain as "exceedingly scorched" and states, "The resources of the country are very scanty in this part of it." This drawing's inscription reads, "From a pencil sketch by an Englishman in the employ of the Hudson Bay Co. of Ft. Nesquelly [*sic*] in the early 70s Edmund T. Coleman." (WHSH 1998.9.74.)

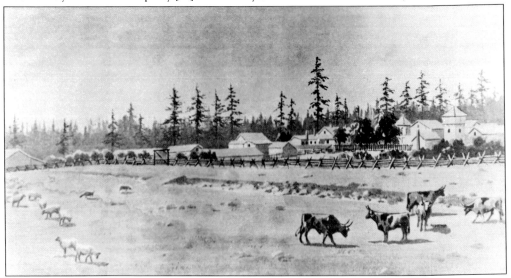

Fort Nisqually's location near Puget Sound, illustrated in this 1843 drawing by Edmund Coleman, was ideal for shipping furs, but food there was scarce. The company log for September 8, 1833, notes, "[We] now feed our people on Dog's flesh." In contrast, the land around Spanaway Lake was lush with fish, game, fruit, and edible plants, making it an ideal location for an outpost. (Fort Nisqually Museum.)

Dr. William Fraser Tolmie, shown c. 1897, was a Scottish surgeon employed by the Hudson Bay Company. He served as Fort Nisqually's doctor and as a trader. Tolmie became the post's chief factor. He documented the animals and plants of the region, and his journals and maps of the company's farms provide the earliest view of Spanaway, its people, and its geography. (HBCA 1987/363-E-700-T/68.)

In 1847, Tolmie drew "Map of Pasture Land Adjoining Cattleherds' Station at Spanueh Nisqually," from which this segment was taken. It shows the company's outpost at Spanueh Lake, including a house next to a spring, an oat field, and a cattle park. A trail labeled "from Walla Walla" runs past the station to Fort Nisqually. John Montgomery was assigned to this station. (HBCA F.25/1/fo.36.)

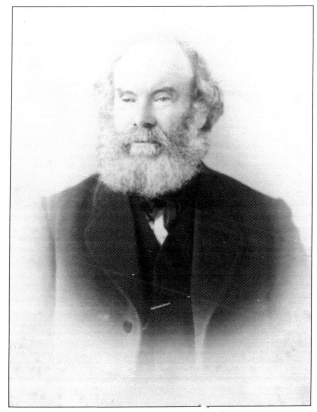

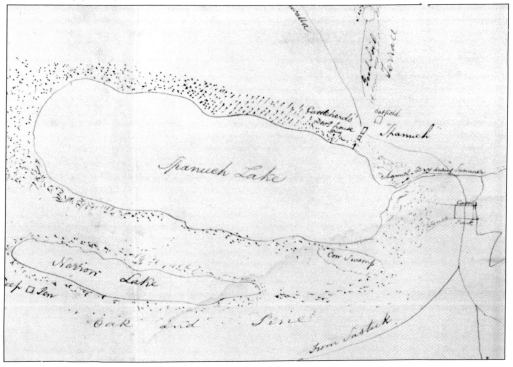

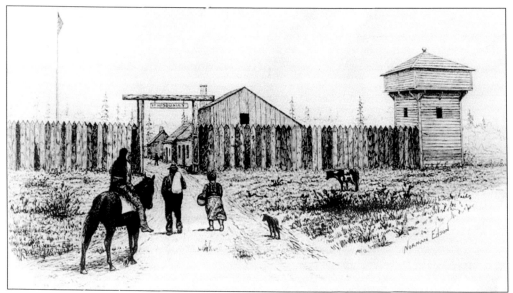

Local tribes had open access to Fort Nisqually, as this Norman Edson sketch shows. The Hudson Bay Company fostered friendly relations by hiring Indians for farm work and by encouraging marriage to its employees. John Montgomery married two or three women of native descent. He remarried after his first (and perhaps second) wife died of illness. (UWL-SC NA4130.)

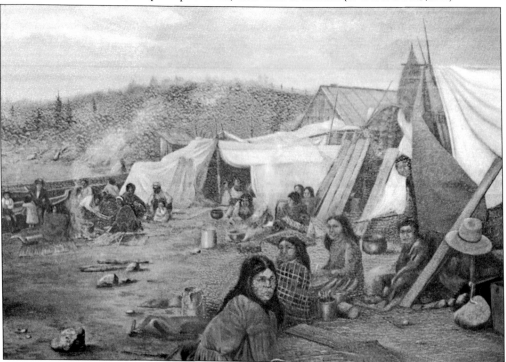

The Hudson Bay Company formed the Puget's Sound Agricultural Company and assigned John Montgomery as its horse and cattle wrangler at outpost Spanueh Station. His assistant was a Native American called "Puyallup Jack." A permanent Puyallup encampment was a little over a mile north of Spanueh Station along Clover Creek. (Pacific Lutheran University Library.)

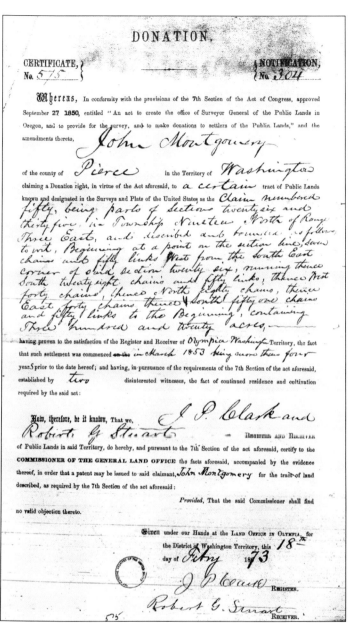

A few immigrants to the Spanueh Lake area staked land claims as early as 1847. However, John Montgomery was Spanaway's first permanent resident, living at Spanueh Station since the late 1830s. Under the Donation Land Claim Act of 1850, Montgomery filed his 320-acre homestead in March 1853 (applicants must have lived on their claim for at least four years before filing and be US citizens). Montgomery had declared citizenship on October 4, 1849, and with affidavits "established by two disinterested witnesses, the fact of continued residence and cultivation required." Friedrick Meyer, George Brown, and John and Allen McLeod (McCloud) were Montgomery's witnesses. Montgomery's place was located on Clover Creek about 1.5 miles east of Spanueh Station. His signature on his donation claim paperwork was in the recording clerk's handwriting with an X labeled "his mark" between the first and last names, indicating that Montgomery could neither read nor write. (TPL.)

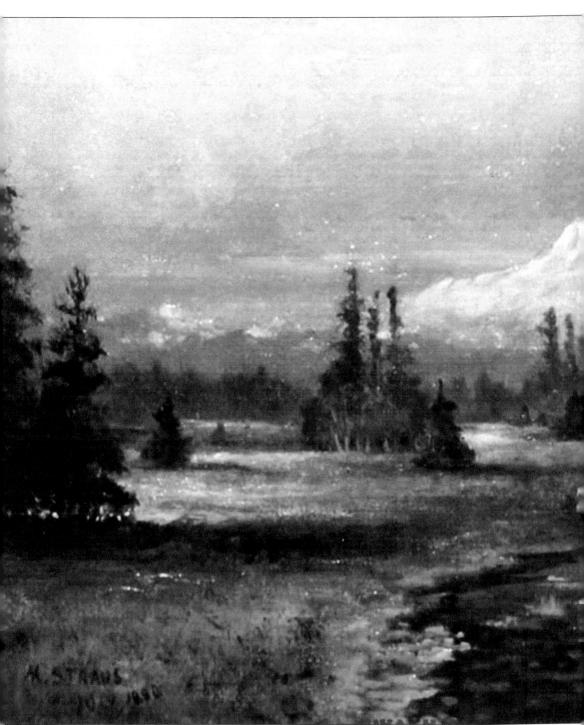

The North American Indians depicted camping along Clover Creek in Meyer Strauss's 1880 painting are likely from the Puyallup tribe. (None of the local tribes had a permanent settlement by Spanaway Lake.) Nisqually tribal elder and historian Hope Cecilia Svinth Carpenter (1924–2010) noted in Images of America: *Nisqually Tribe* that the "traditional lands of the Nisqually reached

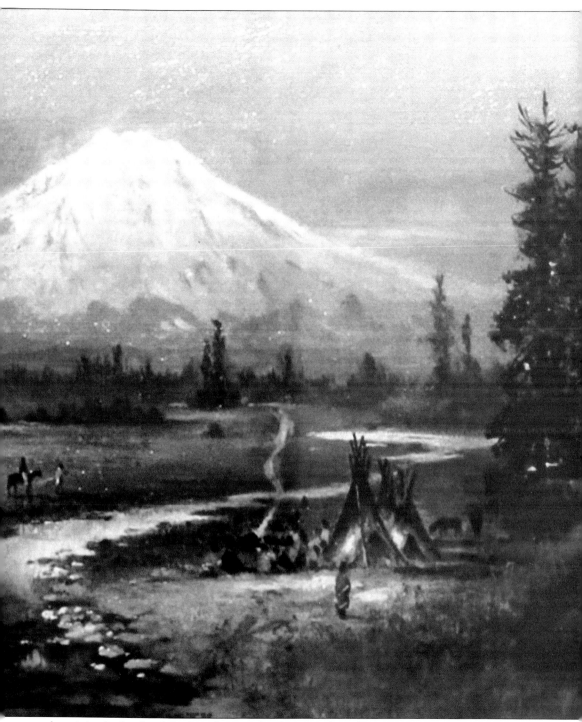

north to join the lands of the Puyallups, with whom we shared 'in-common lands' in and about the present towns of Parkland and Spanaway." Other historians recorded that the Steilacoom tribe also hunted and foraged in the Spanaway area. (WSHS 1970.97.1.)

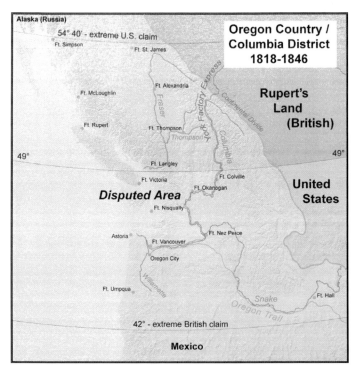

Alaska (Russia)

54° 40' - extreme U.S. claim
Ft. Simpson
Ft. St. James

**Oregon Country /
Columbia District
1818-1846**

Ft. Alexandria

Ft. McLoughlin

Fraser

York Factory Express

Continental Divide

**Rupert's
Land
(British)**

Ft. Rupert

Ft. Thompson

Thompson

Columbia

49°

49°

Ft. Langley

Ft. Victoria

Ft. Colville

Ft. Okanogan

Disputed Area

**United
States**

Ft. Nisqually

Astoria

Ft. Nez Perce

Ft. Vancouver

Oregon City

Willamette

Ft. Umpqua

Snake

Oregon Trail

Ft. Hall

42° - extreme British claim

Mexico

England's and America's shared interests in the Oregon Territory clashed when eastern politicians insisted that acquiring Oregon was America's "manifest destiny." The division of the land became inevitable. England wanted a permanent boundary at the 42nd parallel. US expansionists demanded the parallel "54° 40' or Fight!" An 1846 compromise on the 49th parallel guaranteed the privately owned Puget's Sound Agricultural Company's right to the Nisqually basin and its farms. (Creative Commons.)

Washington Territory became a US possession with the 1846 treaty. Pres. Franklin Pierce appointed his political friend Isaac I. Stevens as governor and superintendent of Indian affairs. Stevens forced heavy-handed treaties and unsuitable reservations on the territory's Native Americans. This led to the Puget Sound War, commonly called the Treaty War of 1855–1856. (WSA A13-8681.)

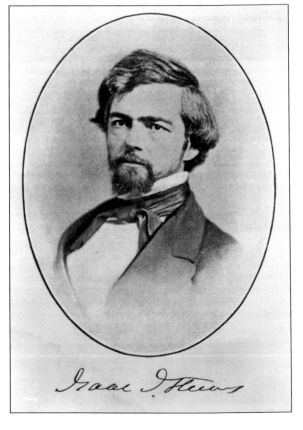

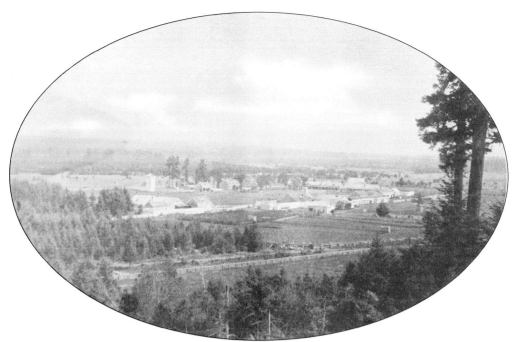

In 1840, the US Army leased land from the British Puget's Sound Agricultural Company to build Fort Steilacoom, shown in 1895. The military presence was partly because of settlers' fears of an Indian uprising but mainly to grab a foothold on land held by the company. Area settlers fled to Fort Nisqually and Fort Steilacoom during the 1855 Treaty War. (WSHS Clark-1951.285.3.)

John Montgomery's cabin was on the hill above Clover Creek along a Fort Nisqually–to–Fort Walla Walla trail. As the site offered a strategic position against attack from the east, Montgomery's home became a key military outpost in the Treaty War. Orders to a quartermaster read, "Move tomorrow to Montgomery's with all your wagons, teamsters, employees, and supplies." (Steve Anderson.)

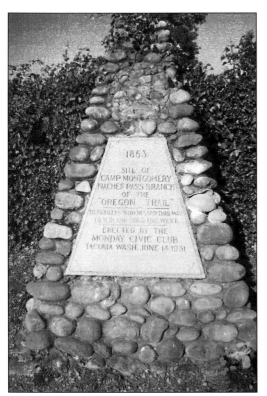

Montgomery's home hosted a military tribunal and a temporary prison. His friends Charles Wren, Lyman A. Smith, and John McLeod were tried at Camp Montgomery for high treason, simply because they remained on their farms unmolested by the warring tribes. Territorial judge Edward Lander was imprisoned for holding civil court after martial law had been declared. All were eventually released. This monument neglects to recognize John Montgomery.

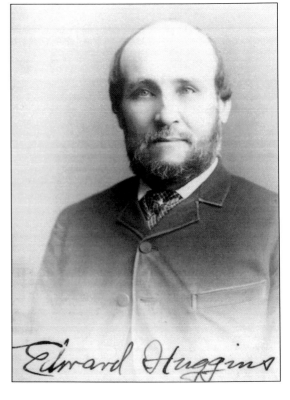

During the 1855 war, Tolmie's assistant, Englishman Edward Huggins, "not feeling any fear of the Indians" volunteered to manage the farms in the Spanaway area. In his *Journal of Occurrences at Muck Station*, he records dismantling "Old Spanaway" because of conflict with settlers. Huggins assigned William Greig, a former US soldier, to rebuild Spanueh Station 1.5 miles farther south. That, too, was abandoned in November 1858. (WSHS 2007.0.227.)

Two

CLAIMS AND CONFLICT

The 1846 treaty with Britain gave the United States most of the Oregon Territory but stated "the farms, lands, and other property of every description, belonging to Puget's Sound Agricultural Company, on the north side of the Columbia River, shall be confirmed to the said company."

Early settlers ignored this provision and were militant about taking possession of the best land. They displaced Native Americans as well; Gov. Isaac Stevens forced the tribes onto reservations to accommodate white settlers.

To encourage Oregon Territory settlement, Congress passed the Donation Land Act of 1850. The act gave 320 free acres (640 if married) if the claimant had worked the land for at least four years by December 1, 1850. Settlers arriving between December 1, 1850, and December 1, 1855, could claim 160 acres. Later arrivals had to pay up to $2.50 per acre.

Only a trickle of pioneers took advantage of the 1850 act in the Spanaway area because of the cost and difficulties of the journey to get there. Those who did took over the agricultural company's farms along Spanaway Lake and Spanaway, Clover, and Muck Creeks. Dr. Tolmie recorded that he tried "to warn off all newcomers, in a pleasant way." The poachers wielded guns in response. Many also took the company's cattle, stole its horses, seized its buildings and fences, and threatened company employees. Despite that, Fort Nisqually offered hospitality and provisions to newcomers, sent Dr. Tolmie to aid the sick, and provided refuge during the Treaty War. But with its farms under siege, Puget's Sound Agricultural Company gave up its holdings—valued at $924,666.66—for $650,000 in 1869. Congress delayed the payment for years.

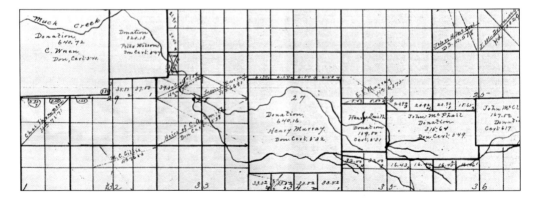

These 1900 maps show the 1850 Donation Land Act claims around Spanaway (marked by heavy borders). Sections with just a name and date were filed under the 1862 Homestead Act. The 1850 act required four years working the land. The 1862 act required five. The settler also had to erect an "18 by 24 building." Some land speculators took advantage of the law's failure to state the 18- by-24 unit of measure and erected an 18-by-24-*inch* building. While land speculation may have occurred in Spanaway, at least all of the dwellings were of livable size. (Both, TPL.)

Territory of Washington }
County of Pierce } *ss—*

Henry W. Jahn being first duly sworn says: That he is fifty four years old and an alien by birth; about the year 1841 he filed his dec= =laration to become a citizen of the United States, in the District Court of Dubuque County in Territory of Iowa.

In July 1852, Henry Jahn staked 320 acres in Spanaway. Jahn's affidavit says he served in the 1st Regiment of Artillery in the Mexican–American War. He came to Fort Vancouver on the USS *Massachusetts*, then was sent to build up Fort Steilacoom. Discharged in 1852, he served again in the 1855 Treaty War. On May 21, 1853, Tolmie noted that he delivered warnings to "squatters on the Company's Claim," including Jahn. (TPL.)

Christopher and Elizabeth Mahon staked their 640 acres on September 22, 1852. Like many early settlers, the Mahons enlisted Native Americans to help clear their land on Clover Creek, paying with part of their crops. This photograph shows, from left to right, the Mahons' sons Bill and George with Bill and Friedrick A. Meyer. (SRL.)

Friedrick Meyer served in the 1st Regiment of Artillery with Henry Jahn. They arrived together at Fort Steilacoom in May 1849. Friedrick staked a 320-acre claim near Jahns's on Clover Creek in June 1853. Meyer had to file a form waiving the continuous residency provision of the Donation Land Act, because "on account of Indian hostilities it was unsafe to stay on his claim." (SRL.)

In December 1857, William K. Melville signed an oath that "the land so claimed by me is for my own use and cultivation," which was required because claims were being filed under false names. John Bradley was witness that "he has known [William and Leuvici] to live together as man and wife" to affirm their right to 640 acres. Seen in this 1906 photograph, the Melville claim was on Clover Creek. (SHS)

Henry de la Bushalier staked a claim in June 1854 on the northeast shore of Spanaway Lake that included most of the lake itself. He hired Friedrick Meyer to finish his cabin and immediately left to fetch his wife, Minerva, from the Dalles. A war party killed him there in July. His widow secured the claim in 1859 and sold it to Peter Morey because she had remarried. (TPL.)

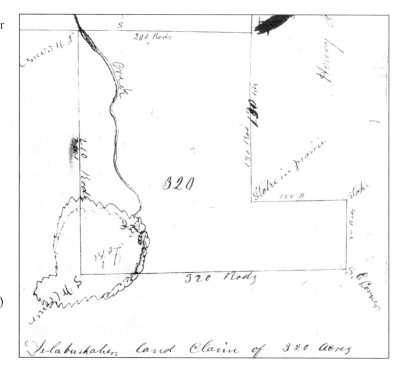

AFFIDAVIT

OF SETTLERS ON UNSURVEYED LANDS, CLAIMING UNDER THE 4TH SECTION OF ACT OF 27TH SEPTEMBER, 1850, AND THE AMENDMENTS THERETO.

Peter J. Moorey of _Pierce_

County, in the Territory of Washington, being first duly sworn, says that he is a white settler on the Public Lands in said Territory, and that he arrived in Oregon on the....1st....day of....May......185.3.

That he is a _Citizen of The United States_

Peter J. Moorey (Morey) claimed 160.5 acres in November 1854. He added to his holdings by buying dozens of parcels of land (with funds from an unknown source) in 1864. He became a stockholder in the Puget Sound and Columbia River Railroad, along with 33 others, including Spanaway-area settlers Henry Murray, Charles Wren, E.S. Fowler, and Fred A. Wilson. (TPL.)

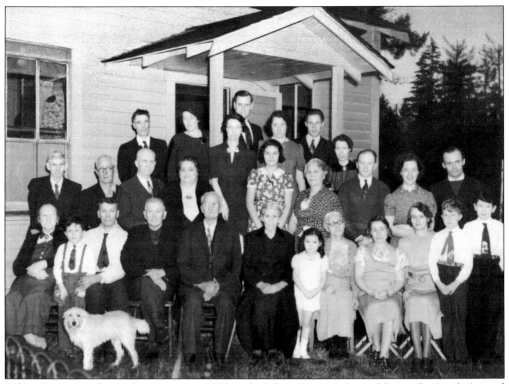

Adam Benston's descendants pose in 1939 with Adam Benston Jr. and his wife, Sarah (seated front, center). Benston Sr. got tetanus after he "had his thumb severely lacerated by the bursting of [his] gun," according to the agricultural company's 1849 log. Benston recuperated and became the hero of one of his noted tall tales, claiming injury while wresting a gun from an Indian who was about to shoot his wife. (TPL D8972No.2.)

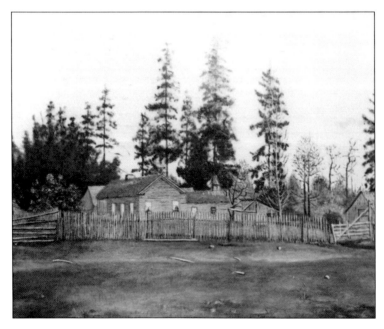

Benjamin Franklin and Frances Jane Wright arrived with their extended family in the Washington Territory on November 15, 1853. Their first claim, as well as the Benston's, was taken for the Puyallup tribe's reservation. The Wrights relocated to Spanaway and Benston moved farther south along Muck Creek. The Wrights had to flee by night during the Treaty War. (SHS.)

Henry de la Bushalier staked a claim in June 1854 on the northeast shore of Spanaway Lake that included most of the lake itself. He hired Friedrick Meyer to finish his cabin and immediately left to fetch his wife, Minerva, from the Dalles. A war party killed him there in July. His widow secured the claim in 1859 and sold it to Peter Morey because she had remarried. (TPL.)

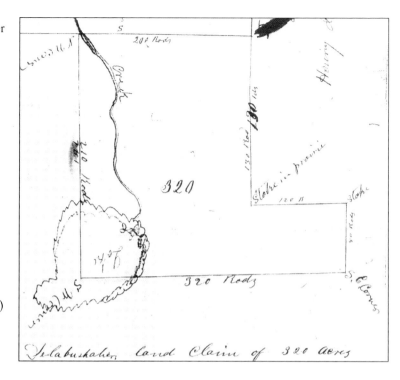

Peter J. Moorey (Morey) claimed 160.5 acres in November 1854. He added to his holdings by buying dozens of parcels of land (with funds from an unknown source) in 1864. He became a stockholder in the Puget Sound and Columbia River Railroad, along with 33 others, including Spanaway-area settlers Henry Murray, Charles Wren, E.S. Fowler, and Fred A. Wilson. (TPL.)

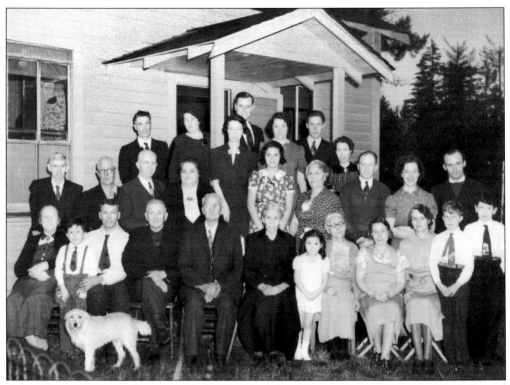

Adam Benston's descendants pose in 1939 with Adam Benston Jr. and his wife, Sarah (seated front, center). Benston Sr. got tetanus after he "had his thumb severely lacerated by the bursting of [his] gun," according to the agricultural company's 1849 log. Benston recuperated and became the hero of one of his noted tall tales, claiming injury while wresting a gun from an Indian who was about to shoot his wife. (TPL D8972No.2.)

Benjamin Franklin and Frances Jane Wright arrived with their extended family in the Washington Territory on November 15, 1853. Their first claim, as well as the Benston's, was taken for the Puyallup tribe's reservation. The Wrights relocated to Spanaway and Benston moved farther south along Muck Creek. The Wrights had to flee by night during the Treaty War. (SHS.)

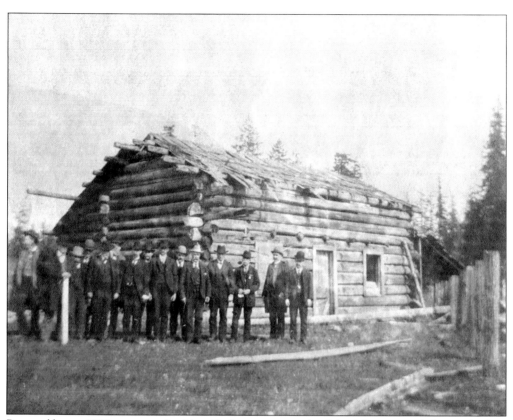

Pictured here c.1900, a group of unidentified men convened at John Montgomery's deserted cabin, which became Camp Montgomery during the 1855 Treaty War. In his oral history, Adam Benston Jr. said, "During the Indian War of 1855 all the settlers went to the post, which was nothing more than an old log barn on the old Montgomery Place." (Fort Nisqually Museum.)

Dr. William Tolmie's "Map of some of the Pasture Land adjoining Shepherd's Station at 'Muck' Douglas Burn, Nisqually" shows the station about 10 miles southwest of Spanueh Station. When Lyman Smith killed the agricultural company's bulls "to keep them from spoiling the breed of his cattle," Dr. Tolmie's only reaction was to contract with Smith and Adam Benston to buy the crops they illegally grew on company land. (HBCA F25/1.fo.34.)

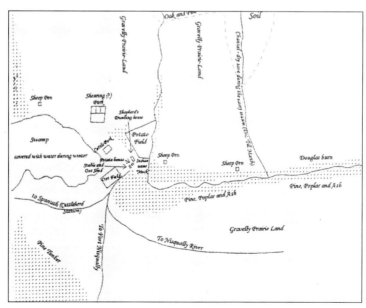

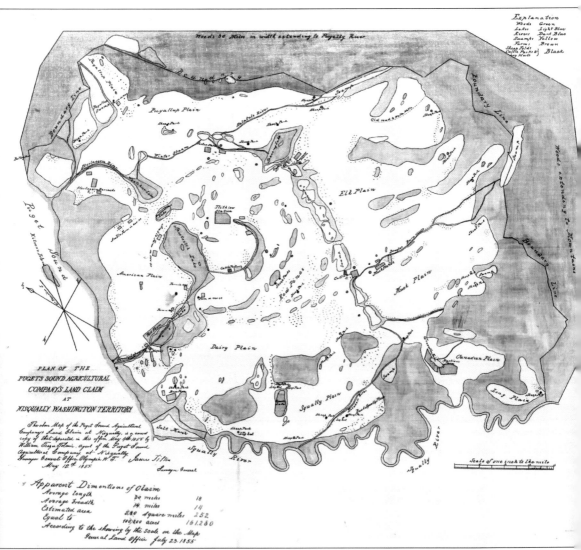

Explanation
Woods Green
Lakes Light Blue
Rivers Dark Blue
Swamps Yellow
Farms Brown
Sheep Folds }
Cattle Parks &} Black
Log Huts

PLAN OF THE
PUGETS SOUND AGRICULTURAL
COMPANY'S LAND CLAIM
AT
NISQUALLY WASHINGTON TERRITORY

After the Douglas Station headquarters was grabbed by former employee Richard Fiander, Dr. Tolmie filed with the territorial legislature this 1855 map, "Plan of the Puget's Sound Agricultural Company's Land Claim at Nisqually," to help define and secure its holdings. Tolmie's journal states that John McLeod (McCloud), Peter Wilson, Charles Wren, Levi Smith, Henry Smith, and Henry Murray confronted the surveyors and "threatened to annihilate our party if we didn't stop." The surveying stopped. (Finished from notes, the map and Spanaway Lake are distorted.) William Greig had taken Montgomery's place as manager of Spanueh Station and reported on May 17, 1858, that settlers "Hadley, Thompson, and Williamson . . . informed him that they had been deputized by the settlers around Spanaway to warn him not to bring the Company's sheep onto [Spanaway's] plains." The company took its grievances to the territorial court. The political patronage of local settlers carried more weight than a distant federal government's British-American treaty—the court found in favor of the settlers. The company's tenure on the Nisqually Plain came to an end in 1869. (WSA AR-270B-003459.)

26

Three

ROADS AND RAILS

Travel within the Nisqually plain was difficult because of a lack of decent roads, and Spanaway settlers were isolated from their neighbors. The Cascade Range was a formidable barrier to the rest of the nation.

To reach Walla Walla from Spanaway, travelers had to canoe down the Cowlitz River to Portland, impeded by "torturous channels," seasonal flooding, and log jams. Alternately, the courageous could trek to the shore of Puget Sound and make a turbulent ocean journey to the Columbia River and across its treacherous bar. A riverboat trip up the Columbia meant several miles-long portages before finally arriving east of the Cascades to pick up some mode of land travel into the interior.

Spanaway entrepreneur Peter J. Morey and 33 others formed the Puget Sound and Columbia River Railroad Company to run a line along the Cowlitz to the Columbia (and ease at least that leg of the trip). Lack of funding thwarted their plan. The real solution was a railroad across the Cascades directly into Puget Sound. Portland financier Henry Villard controlled the Columbia River transportation route and trade east of the mountains. When the Northern Pacific selected Tacoma as its terminus, Villard secretly bought a controlling interest in the Northern Pacific and diverted it to Portland to protect his monopoly. Only when the competing Burlington Northern was making its way to Seattle did Villard allow the Northern Pacific to run a main line to Tacoma through Stampede Pass.

Without a navigable waterway linking them to Puget Sound, early Spanaway settlers had to traverse Native American trails intended for travel only by foot or horse. So, the homesteaders took axe, saw, pick, and shovel in hand to widen the trails for wagons. Dense stands of trees made it a Herculean task, as this undated photograph shows. (TPL G66.2-049.)

Conflict between settlers and Native Americans made roads a military concern. In 1853, the Army instructed Capt. George McClellan to build a road from Fort Steilacoom to Fort Walla Walla east of the Cascade Range. He failed and wasted the money, leaving citizen volunteers to fund and widen the Native American trail that cut through Naches Pass, seen with snow in July in this c. 1925 Asahel Curtis photograph. (WSA AR-04503045.)

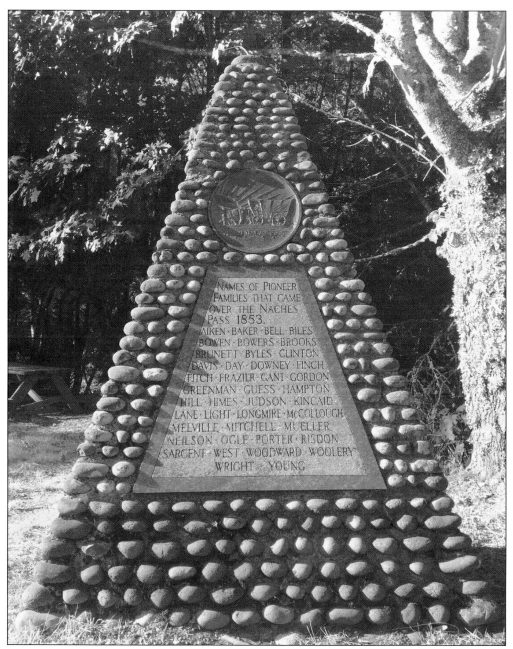

NAMES OF PIONEER
FAMILIES THAT CAME
OVER THE NACHES
PASS 1853.
AIKEN · BAKER · BELL · BILES
BOWEN · BOWERS · BROOKS
BRUNETT · BYLES · CLINTON
DAVIS · DAY · DOWNEY · FINCH
FITCH · FRAZIER · GANT · GORDON
GREENMAN · GUESS · HAMPTON
HILL · HIMES · JUDSON · KINCAID
LANE · LIGHT · LONGMIRE · McCOLLOUGH
MELVILLE · MITCHELL · MUELLER
NEILSON · OGLE · PORTER · RISDON
SARGENT · WEST · WOODWARD · WOOLERY
WRIGHT · YOUNG

A monument in Greenwater on today's Highway 410 lists the families who made an arduous journey by wagon train in 1853 over the Naches Pass. They mistakenly believed the military road was complete. Work had begun on both sides of the pass, and a road was cleared from the west over the pass and partway down the east side. The work party on the east side had made little progress and abandoned the job. So, the members of what became known as the James Longmire wagon train, already worn from 62 crossings of the Naches River, had to cross the Greenwater and White Rivers another 22 times, lower their wagons down precipitous cliffs, and cut their own way through dense forest. Spanaway settlers William Melville and Benjamin F. Wright and his family were members of the Longmire wagon train.

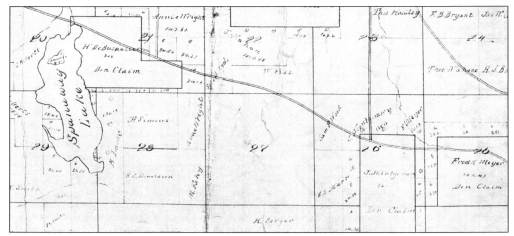

This drawing from an 1889 map shows the military road from Fort Steilacoom to Fort Walla Walla, skirting Spanaway Lake and crossing Bushalier's, Montgomery's, and Meyer's claims. The towering Cascades and the snaking Naches River made the way so difficult that this route was abandoned. Military Road through Spanaway is still a major traffic corridor.

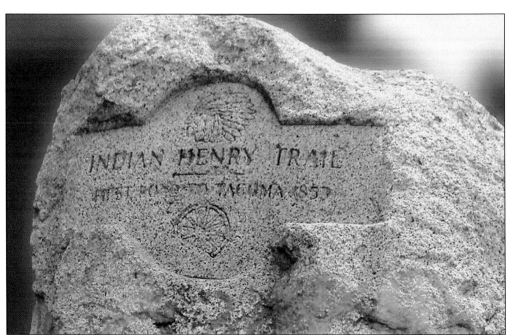

Indian Henry lived south of Spanaway in the Muck Creek area and traveled frequently to the sound. By 1850, his trail had become "the first road to Tacoma" for farmers and loggers, as this monument notes. Intersecting the Naches Trail at the northeastern tip of Spanaway Lake, these two main travel routes placed Spanaway at the crossroads—and sometimes in the crosshairs—of events.

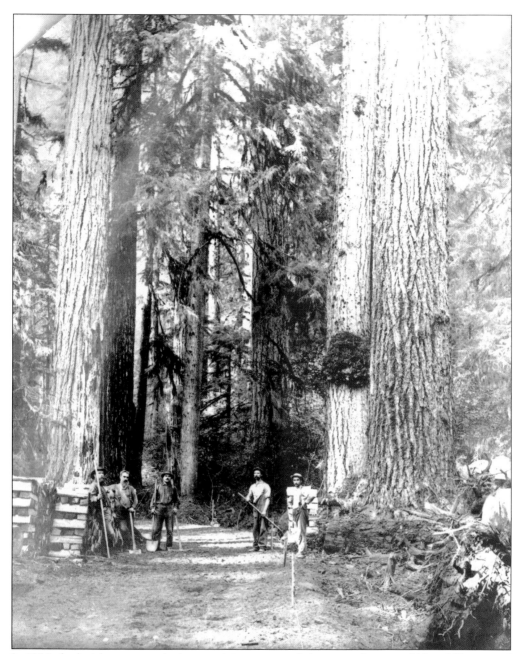

In 1854, the legislature passed a law requiring every male between the ages of 18 and 50 to spend three days a year building roads. Preachers and the infirm were exempt. One additional day of labor was ordered for each $1,000 of taxable land value, with the Spanaway area assessed at $1 per acre. In 1857, a poll tax of $25 per $100 of land value was added. Those who did not pay were not eligible to vote, but another two days of work on road construction could be substituted for the poll tax. Spanaway resident Thomas J. Wright became supervisor for road district three, which included Spanaway. A powerful position, road supervisors could order male citizens in their district to report with their tools at 7:00 a.m. and could sue to fine those who did not comply. (TPL Wil [B]068.)

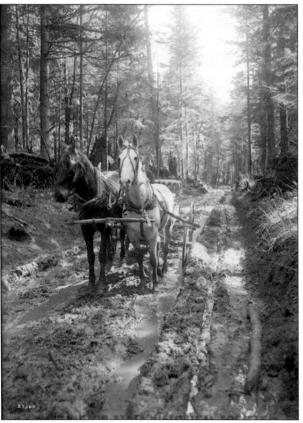

Indian Henry's trail between Tacoma and Mount Rainier became National Park Highway in 1899. Locals called it Pacific Avenue after their original main street, which was renamed Park Avenue. Once it was paved in 1926, Tacoma claimed the highway as their Pacific Avenue "Extension" to keep the upper hand. (Wayne Cooke family.)

Wagon roads were an improvement over Native American trails but not by much. Dusty and rutted in dry weather, they became nearly impassable quagmires when it rained. This c. 1912 photograph shows the main road through Spanaway to Mount Rainier. Robert Creso Sr. recalls that the trip in his parent's 1914 Studebaker took 11 hours on dirt roads with "ruts 6 to 8 inches deep in some places." (WSHS 1943.42.23360.)

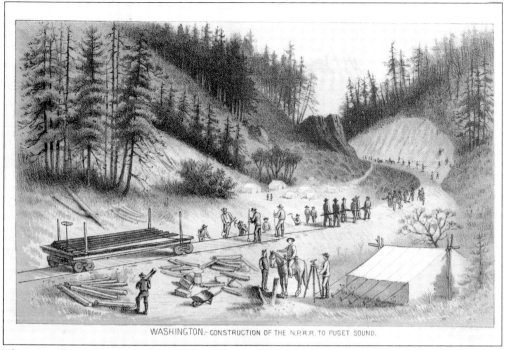

This 1886 illustration shows workers laying Northern Pacific Railroad tracks through the Cascades to Puget Sound in 1873. The railroad finally addressed what Olympia's *Columbian* newspaper called "the struggle attendant upon gaining admission" to the northern part of the Oregon Territory by means other than "wretched roads." (WSHS 2006.132.6.)

In 1889, the Lake Park Land, Railway and Improvement Company bought claims east of Spanaway Lake but not without a bit of political hanky-panky. J.B. McMillan and his wife beat the railway to a key parcel for $1,600. The company sued, stating, "Said defendants had no right or title to said premises." It won. McMillan was forced to forfeit the land to the railway company for $1. (Marietta Miller.)

Calvin L. Curtis, James D. Miller, Ira W. McCallister, William Borroughs and James E. Alsop,

-To-

The Public.

Articles of Incorporati
Dated October 29, 1889
Ack'd October 29, 1889
Recorded October 30, 18
At 11:10 A.M.
Book 3 A. of I., Pages
487,488,489,490, & 491.

Corporate Name;
 Lake Park Land, Railway and Improvement Company.

Objects: (With others)
 The acquisition of all kinds of agricultural, timbe
coal, mineral, stone, gas, oil, and other lands and real
estate of every character and description, whether in pur
suance of the laws of the United States, or by purchase o
otherwise, from individuals, companies, or corporations,
and either in fee leasehold or other interest or estate.
To locate, buy, sell, own or operate mines. To buy, sell,
transfer, hypothecate, plat, divide and subdivide lands.
To establish, lay off, and plat townsites and additions t
towns, cities, or villages, and to subdivide, plat and la
out into streets, blocks and lots such real estate, as sa
companies may own or lease in the same manner as individu
might do.

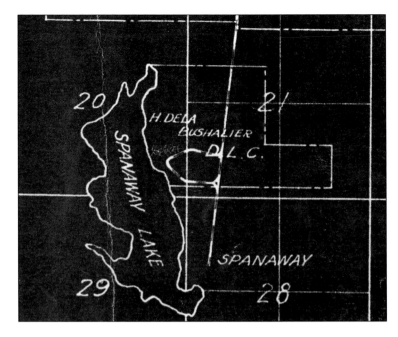

This diagram shows the Lake Park Land, Railway, and Improvement Company rail line from Tacoma to its new town, Lake Park (Spanaway). The company had secured an easement for $1 across Bushalier's land from Tacoma Light and Power, which had acquired that claim. The rail line looped down to the lake for access to the beach and boathouse that Tacoma Light and Power had created.

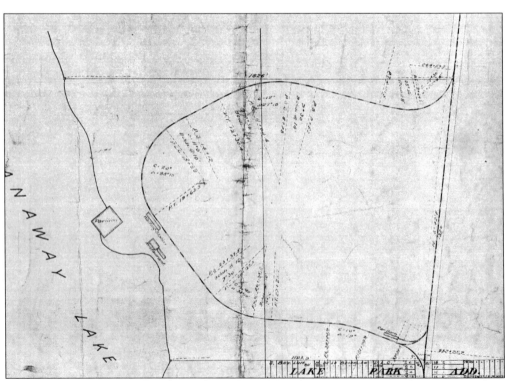

This section of an 1891 railroad map shows the rail line loop to Spanaway Lake with a pavilion on the shore and a restaurant and waiting station nearby. Since its operator was a Spanaway resident, Charles Daniels, the trolley was kept overnight in a car barn at the southeast corner of the loop for the next day's first run.

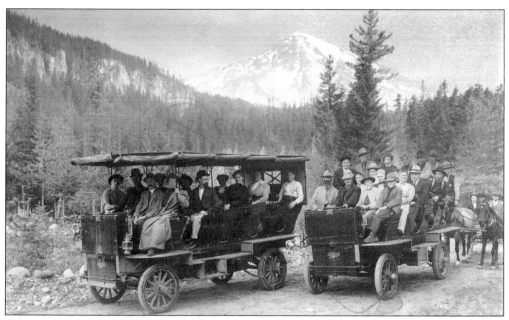

When Mount Rainier was made a national park in 1922, tourists rode the rail to its end at Fourth Street and Pacific Avenue (now 164th Street and Park Avenue) in Lake Park (Spanaway). They got off at a depot across from the Exchange Saloon and spent the night at the Lake Park Hotel. Every day at 9:00 a.m., the tourists boarded motorcades for another two-day journey to Mount Rainier. (UWL-SC 1965.87.1.)

Before 1890, Spanaway's Exchange Saloon existed as a loggers' playground, affectionately called "The Bucket of Blood." The Lake Park railway brought a more refined trade, but as was custom of the day, women were not allowed. Ladies could partake of a beverage in an adjacent building called the Wine Room. Eventually, state law deemed hard-liquor places "saloons" and those that served only beer and wine as "taverns," hence, the Exchange had to drop "saloon" from its historic name.

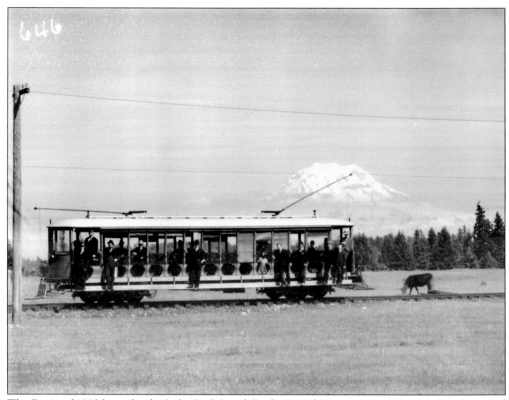

The Panic of 1893 brought the Lake Park Land, Railway and Improvement Company to financial ruin. The Tacoma, Lake Park, and Columbia River Railway bought the line to Spanaway. The Tacoma company's November 1897 timetable showed that its high-speed electric streetcars, pictured here in an A.H. Barnes 1907 photograph, would depart Tacoma at 10:35 a.m. and arrive in Lake Park at 11:35 a.m. (UWL-SC BAR371.)

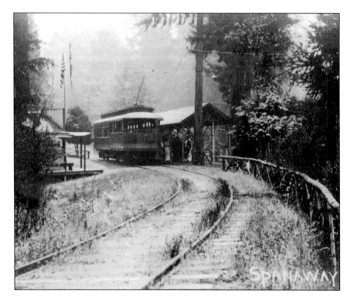

This photograph shows the streetcar waiting station at Spanaway Park. The Tacoma, Lake Park, and Columbia River Railway changed its name to Tacoma and Columbia Railroad Company in 1895, because it planned to extend its Spanaway line south to the Columbia River. The politically powerful Northern Pacific Railroad thwarted the plan. Its subsidiary, the Tacoma Railway and Motor Company, forced the Tacoma and Columbia out of business. (WSHS 1994.36.1)

According to the August 1, 1893, issue of the *Daily Ledger*: "[Lake Park railway officials] did not desire the TR&M [Tacoma Railway and Motor] Co. to refuse to carry their passengers this morning from Lake Park, fearing the many men who are employed in the city and live at Lake Park would forcibly object and cause trouble for the road . . . The Northern Pacific is simply using the T.R.&M. Co. as a catspaw." (TPL.)

T. R. & M. CO. ENJOINED

From Abrogating Their Contract.

WITH LAKE PARK RAILROAD.

I: I₄ Cla'm d To .Be a Scheme of the N. P. R. R. Co. To Prevent an Ex-tension to the Columbia.

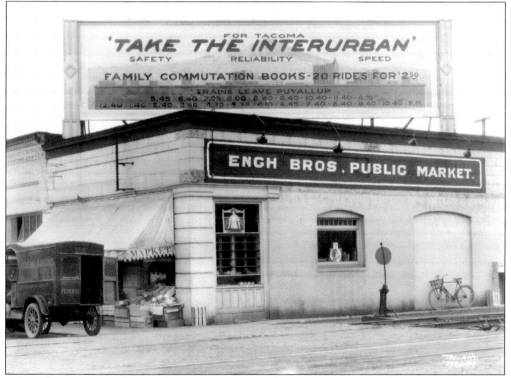

When the Tacoma Railway and Motor Company took over the Tacoma and Columbia rail lines, it connected Spanaway to rails running from Seattle to Steilacoom and a dozen towns in between. Service from Tacoma looped through Puyallup before connecting with the original Lake Park Land, Railway, and Improvement Company's line. This 1922 interurban billboard in Puyallup advertises family ticket books, "20 rides for $2.50." (TPL B6099.)

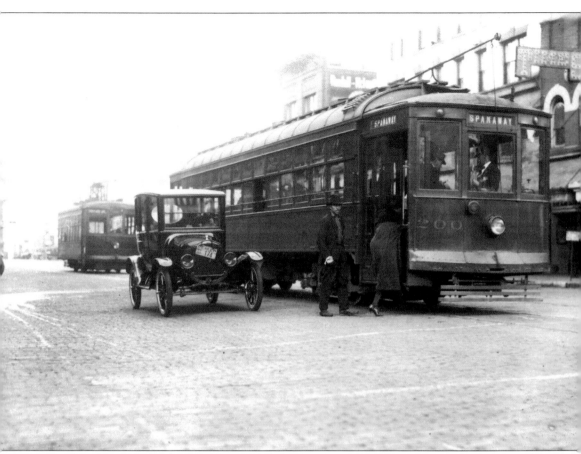

In this 1921 photograph, passengers board the Spanaway streetcar in downtown Tacoma; they were unknowingly riding the Northern Pacific Railroad. While the Northern Pacific's federal charter prohibited it from building branch lines, it was allowed to buy existing lines. So, the railroad formed corporations, had them build spurs, and then transferred ownership to itself. One of these companies, the Puget Sound Electric Railway, bought the Tacoma Railway and Motor Company that had been operating the Spanaway service. They combined it with Pacific Northwest Traction to form the Puget Sound Traction, Light and Power Company, whose owners were in Massachusetts. This cobbled-together firm took control of the Lake Park (Spanaway) run. The growing use of improved automobiles and better roads quickly spelled declining passenger income, bankrupting the interurban service. It abandoned all its lines and service to Lake Park in 1928. (Some sources say the line operated until 1938.) (TPL G66.2-015.)

Four

GROWTH AND PROSPERITY

Before the arrival of the Pacific Northwest Railroad to Tacoma in 1888, settlement around Spanaway Lake was sparse. Immigrants weary from the months-long passage by ship around Cape Horn found it easier to stay in San Francisco or, if they managed to reach Puget Sound, to settle along its shores. Those making the long and difficult trip by wagon over the Oregon Trail to Portland tended to turn south for the easier route into the Willamette Valley. After the Northern Pacific Railroad punched through the Cascade Mountains to Tacoma, it brought with it a surge of immigrants. Farmers found the Spanaway area largely free of trees and the land productive. Water was abundant because of Spanaway Lake and the springs, creeks, and swamps all around it.

Some found a good living on the land. Others became wealthy by investing in real estate or plying their trades. They gave their wealth and time to the school board and road district and served as jurists and in the state militia. But to East Coast financiers, corporate moguls, railroad magnates, and distant politicians, Spanaway was simply a resource to exploit.

This chapter views Spanaway in the late 1890s and early 1900s, chiefly through the Creso and Lee family photographs. Dorothy Thompson Winston's *Early Spanaway* (available at the Spanaway Historical Society) records the stories of other Spanaway pioneers.

In 1860, Capt. Amos Greenlaw sailed his ship, loaded with sawmill equipment, on the four-month journey around Cape Horn to Puget Sound. He built a sawmill at Tumwater and used the steam winch on his ship to build a "steam donkey" to mill New England–style house kits for settlers. There, he married his second wife, Alice Greig, daughter of William Greig, who was Spanueh Station's last manager. (SRL.)

John Wilson Roberts built this home on the west side of Spanaway Lake c. 1867. He kept a daily Spanaway Farme journal that detailed the weather and interaction with other Spanaway settlers. He never married; however, when he died in 1914 without a will, a sensational legal fight for his $90,000 estate ensued. One supposedly long-lost granddaughter went to jail for fraud and conspiracy. Roberts's brother George and two nieces inherited his estate. (TPL.)

Capt. Amos Greenlaw sold his sawmill in Tumwater and retired in Spanaway with one of his daughters, Charlotte, on the former George Brown donation claim next to Friedrick Meyers. This portrait shows Greenlaw's third wife, Meyer's daughter Wilhelmina, whom he married on July 20, 1868. The fate of his first two wives is unknown. (SRL.)

In 1873, Gustav Bresemann settled at the north end of Spanaway Lake. In December 1888, Bresemann sold his claim, except for a large parcel with his house, to the Tacoma Light and Power Company for $20,000. The sale included his millpond with "all water rights to Spanaway Lake and Bushalier [Morey] Creek." Shown c. 1905, from left to right, are Paul Bresemann, C. Stoever, and Bertha Bresemann. (TPL BSM-B8.)

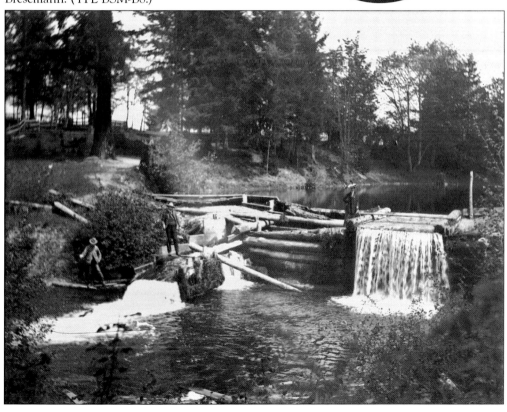

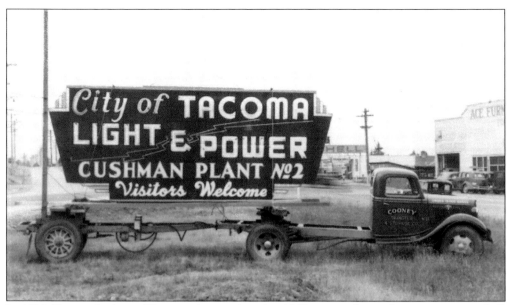

In 1888, Tacoma Light and Power, advertised in this 1942 image, also took an easement and all Clover Creek water rights from Friedrick Meyer, paying him $5,000. John Montgomery relinquished his rights for $150. The company condemned land across dozens of parcels, including William and Annie Meyer's, James Rigney's, Johanna Moorey's (Morey), and Murty Fahy's. An ill-constructed wooden flume delivered Spanaway's water to Tacoma. (TPL Richards, M38-1.)

John Wilson Roberts received a letter on this letterhead that said, in part, "D Sir, You are hereby notified that the $1,000 due on Subsidy Contract No. 3-6 is now wanted to buy [illegible] material to be used in the construction of the Lake Park and Tacoma Ry." Roberts invested in the Lake Park company and became quite wealthy. (TPL.)

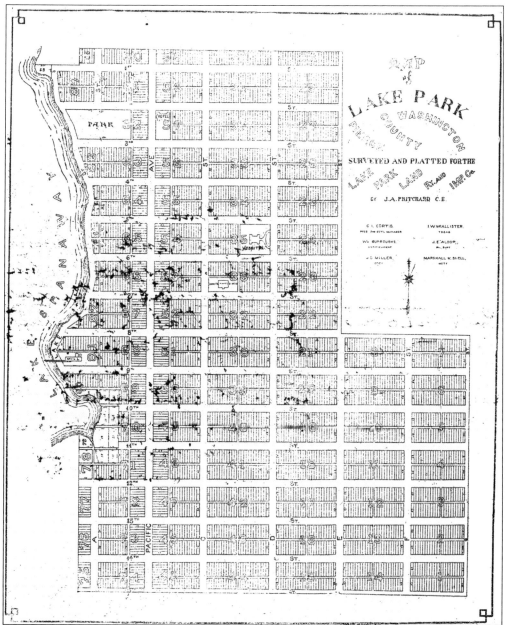

Tacoma Light and Power formed the Lake Park Land, Railway, and Improvement Company and, in 1890, deeded to its subsidiary for $1 an easement across the Spanaway-area land claims. The Lake Park company bought the land along Spanaway Lake's east shore, south of the Bresemann donation claim, to plat as Lake Park, shown here in the company's map. "Wise or Otherwise," the developers' advertisements touted, "It is not the purpose of this company to speculate on the credulity of the public but to furnish cheap and pleasant homes to the poor as well as the rich." Lots cost between $30 and $75, "terms one-third cash, one-third 6 months, one-third 12 months, interest 6 per cent." The town would be "connected with Tacoma by telephone and telegraph" and "for the small sum of 6-2/3 cents" commuters could ride to town 20 minutes away on the "first class electric street railway." (TPL.)

43

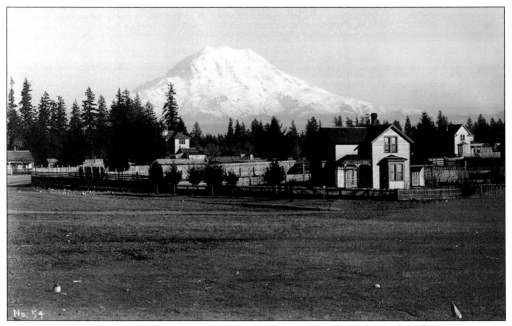

The Lake Park railway company's "Wise or Otherwise" flyers extolled Lake Park (Spanaway) as "an ideal suburban village" with "a diversified panorama of beautiful valley, placid water, rugged mountain and majestic snow capped peak." That much was true, as this 1907 photograph by A.H. Barnes shows. (UWL-SC BAR201.)

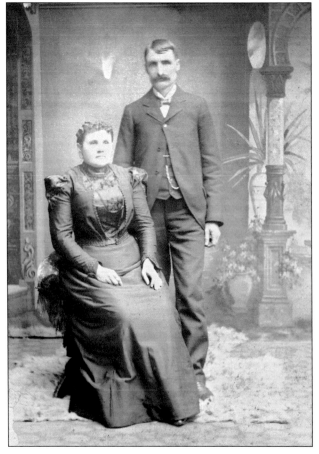

Emma Morrison and Lee Allbert settled southeast of Spanaway in the late 1880s. Allbert was one of several Spanaway men who worked for the Lake Park railway. He was likely involved in a 1917 railway strike, as the rail company was unsuccessful at keeping the streetcar running to Spanaway with the strikebreakers it had hired. (Wayne Cooke family.)

EGERMAYER'S ADDITION
TO LAKE PARK ON
SPANAWAY LAKE.

Joseph Egermayer platted the section between the Bushalier's and Jahn's donation claims. Egermayer's 1892 sales flyer claimed that "with no stumps to clear away and no holes to fill up" and "thickly settled with farmers," his land was "the best opportunity." Lots sold for $50 to $95 with a "first payment [of] $10 or 15. Balance $5 monthly without interest." (WSHS EPH-A 979.77816.)

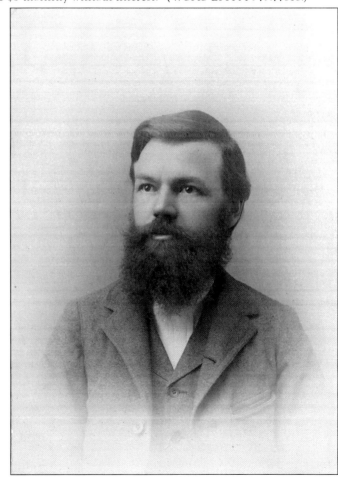

In December 1890, Tacoma businessman A.W. Stuhrman, shown in this 1897 portrait by Lindahl, founded the *Spanaway Sentinel* weekly newspaper. Austin M. Nicholson published the paper in Spanaway. The *Sentinel* noted that investing with the purveyors of Egermayer's Addition or Simon's Addition to Lake Park "should pay 50 percent in six or ten months." (UWL-SC POR 568.)

Land speculators found lack of proximity
to Spanaway no deterrent. In 1890, W.C.
Boggs of Tacoma and A.C. Boggs of
Vinton, Iowa, promoted the main feature
of their Clover Lea Addition to Tacoma.
"This beautiful addition is quickly
reached by two Motor lines—one going
right through it to Spannaway [sic] Lake,
that fine Summer resort." (WSHS EPH
979.77816 B634C.)

In this c. 1890 photograph, the Lake
Park Land, Railway, and Improvement
Company steam train stops in front of its
luxurious, 72-room Lake Park Hotel. Lake
Park brewery owner Joe Geiger built the
hotel under contract from the railway. It
burned in 1904, along with a store and a
Catholic church. (UWL-SC SAR037.)

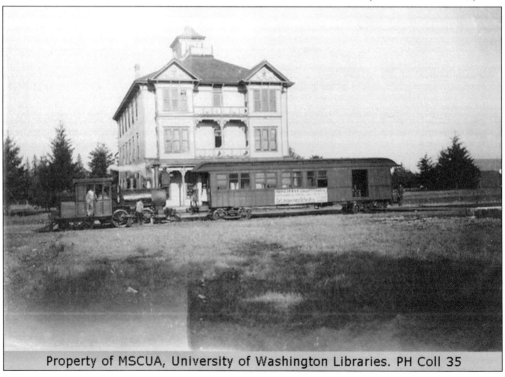

Property of MSCUA, University of Washington Libraries. PH Coll 35

The Exchange Saloon, where this 1890 peanut vendor is peddling his wares, was next to the Lake Park Hotel. The peanut man's image was found in 1985 in the Exchange attic. The Exchange still serves this popular bar snack and insists customers throw the shells on the floor. Foot traffic across the shell-littered floor creates natural cleaning, oiling, and preserving of its ancient floorboards. (Exchange Tavern.)

Lake Park's Creso Hotel was on the southwest corner of Second (161st) Street and Pacific (Park) Avenue, on the west side of Pacific. The Creso Hotel was originally a boathouse hotel on the lake. It was moved by Peter C. Creso, remodeled, and then sold to A. Anderson. Recycling buildings was common practice. (CCC.)

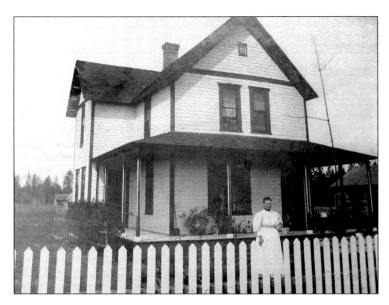

Wilhelmina (Meyer) Greenlaw is shown in front of her home on National Park Highway (Pacific Avenue) and what is now 146th Street, where she moved after her husband Amos Greenlaw died. Her house became the La Pergola Italian Restaurant, a popular stop for travelers to Spanaway Park or Mount Rainier. This building burned to the ground on March 18, 1947. (SRL.)

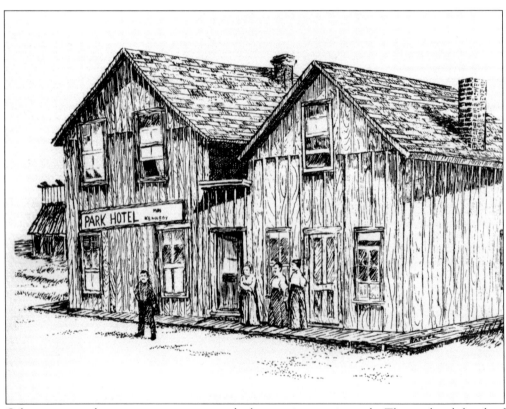

Other accommodations sprang up to serve the burgeoning tourist trade. This undated sketch of the Park Hotel, a bit more rustic than the Lake Park or Creso Hotels, shows proprietor Hortense Kennedy with her two sisters and an unidentified man. The Spanaway Athletic Club met here while William C. Fowler was president. (Dorothy [Fowler] Fitts.)

Adolph Beeman came west with Simeon and Hortense Kennedy and became Lake Park's deputy sheriff in 1906. Home brew was one of Beeman's culinary skills. In this photograph, he displays squash in his garden. Roadwork (provided by settlers and paid for by road taxes) improved access to Tacoma and Steilacoom and gave Spanaway farmers, like Beeman, markets for their produce. (SHS.)

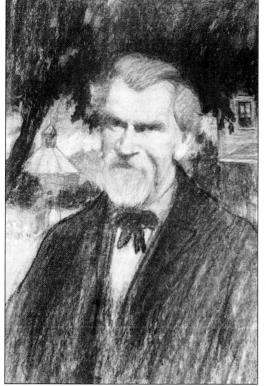

Robert Locke found his fresh vegetables to be rare and in great demand at Fort Steilacoom, on the sailing ships, and among Tacoma land survey crews. Robert and Elizabeth Locke had come west by rail to San Francisco with Gustav Bresemann before sailing up the coast to Steilacoom in 1870. Steilacoom's soldiers told Locke about "a nice place that would require no clearing, with good spring water"— Spanaway. (CCC.)

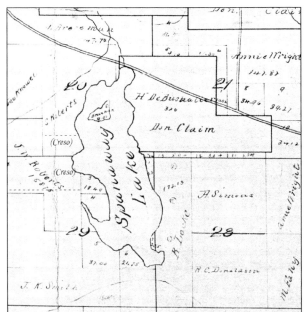

Locke's 360-acre claim along the eastern shore of Spanaway Lake included Spanueh Station. It bordered the original Bushalier's claim on the north. Robert Creso Sr. said Locke was a rope maker by trade. Locke went to the mountains for tree moss and "made rope [from the moss] for the Indians to get them to help him build his cabin and put in his first garden." (TPL.)

"A man could just about live off the land," said Robert Creso Sr., describing wild strawberries, mushrooms, cranberries, and game. "My uncles used to fish for trout in the ditch on grandfather's ranch, using two to three hooks on a line, catching beautiful, good-sized trout." In this July 1907 photograph, an unidentified boy fishes with a stick pole at a millpond on Clover Creek. (Stiegler family.)

The sign at the back corner of this house advertises "Easy Terms" for lots. The two older people in this 1885 photograph are believed to be Anne and Andrew Simons, who settled a claim next to Robert Locke's and stayed with him until their own house was completed. Simons platted and sold much of his land as the "Simons Addition to Lake Park." (CCC.)

In 1889, John Wilson Roberts sold part of his land to Peter C. Creso. Creso, shown with his wife, Minna, also ventured into real estate, buying Tacoma's Edison Hotel for $1,600 and remodeling it. Creso had the street in front of the hotel surveyed, causing speculators to think that the Union Pacific Railroad was coming through as rumored. Although the railroad rumors were untrue, Creso was able to sell the hotel for $7,000. (CCC.)

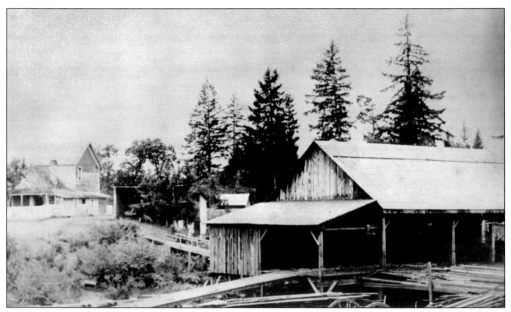

Locke built a larger house with lumber from the mill pictured here, which was owned by Bresemann. Locke sold his house and land for $650 to the Lake Park Land, Railway, and Improvement Company and moved to Old Tacoma. There, he opened a hotel and employed Chinese help to cater to ships from the Orient. After four years, the Lockes returned to Spanaway and bought a ranch. (CCC.)

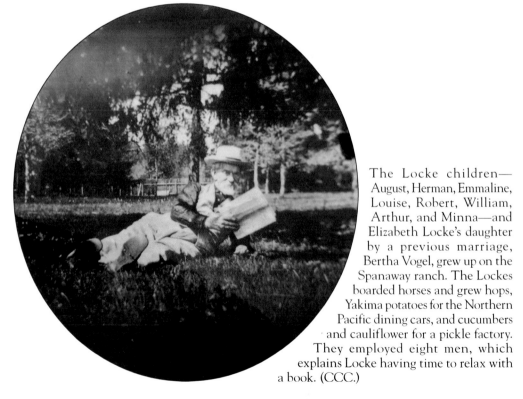

The Locke children—August, Herman, Emmaline, Louise, Robert, William, Arthur, and Minna—and Elizabeth Locke's daughter by a previous marriage, Bertha Vogel, grew up on the Spanaway ranch. The Lockes boarded horses and grew hops, Yakima potatoes for the Northern Pacific dining cars, and cucumbers and cauliflower for a pickle factory. They employed eight men, which explains Locke having time to relax with a book. (CCC.)

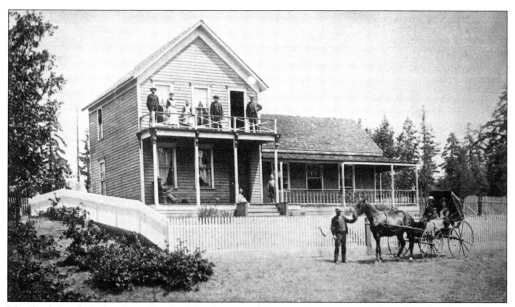

Elizabeth Locke's daughter Bertha Vogel married Gustav Bresemann. Their five children, shown on the porch of the Bresemann home (order unknown), are Gertrude, Paul, Emanuel, Bertha, and Gustav (Gus). The Lockes were frequent visitors; Minna and Peter Creso and their son Robert appear to be the family in the surrey. (CCC.)

Peter and Minna Creso raised three children. Shown from left to right are Robert Sr., Magdalene (Lena), and Chester P. (Chet). Lena was the daughter of Peter's first wife. Robert Creso recalled that his father, a tinsmith by trade, made butter tins to send to Alaska during the gold rush and that Chester P. Creso "shipped stoves by the boatload to Seattle." (CCC.)

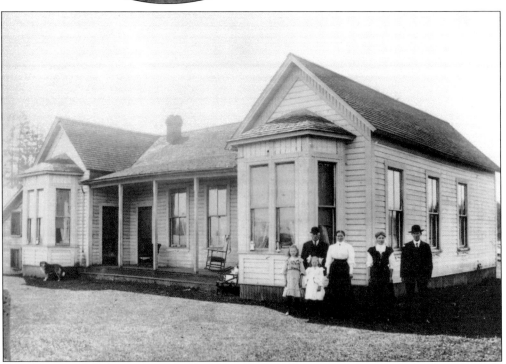

In 1907, an epidemic of life-threatening spinal meningitis swept the country. Robert Creso Sr. was seven years old when he became infected. For three weeks, Creso was unconscious and paralyzed on his right side. After he recovered, he had to relearn how to walk. (CCC.)

William and Martha Schultz settled south of Spanaway Lake. Peter C. Creso was on the school board and gave Schultz a silver dollar to seal Schultz's offer to donate two acres for a new two-room school. Schultz later tried to rescind the offer, but his attorney advised, according to Robert Creso's memoir, "Give the district a deed or the court will do it for you." (SHS.)

Peter C. Creso and his wife, Minna Locke Creso, are in the front row of this family photograph. The second row shows their sons Robert (left) and Chester (right) and Peter's daughter Magdalene (Lena). Minna Creso drew the plans for the second Spanaway school, called Whittier, which was located on the William Schultz property. (CCC.)

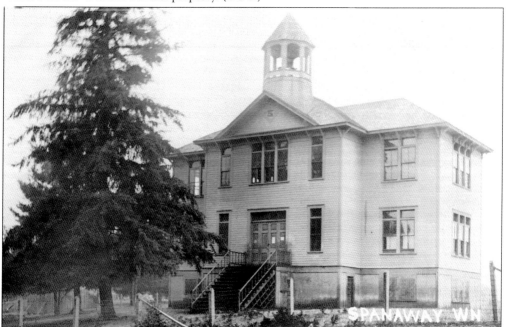

Schools were built and funded by local citizens until, in 1860, the Washington Territory legislature set a minimum three-month school year and allocated $148.77 for 36 Spanaway students. Shown is this undated photograph, the school was the third for Spanaway children. It was built in 1891 on A. Simon's property at Seventh (166th) Street on the west side of National Park Highway between A and B Streets. (Wayne Cooke family.)

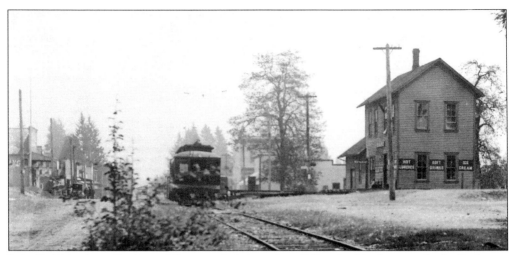

Lake Park's business district rapidly expanded along the rail line. In this photograph, the Exchange Saloon is the first building on the left and Ballard's grocery and rail depot is the first building on the right. Ballard's did not have much of a selection of groceries, but—more important in the memory of neighborhood kids—it had a soda shop. (Wayne Cooke family.)

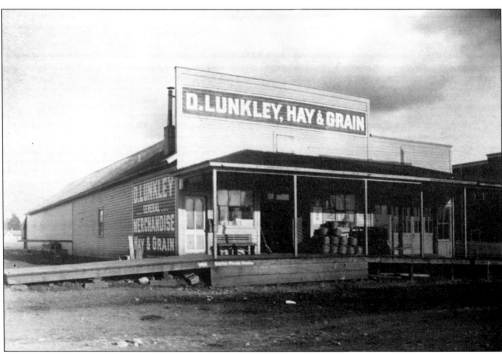

Dan Lunkley's General Merchandise Store on Fourth (163rd) Street and Pacific Avenue (now Park Avenue) could meet just about any need. It stocked groceries, clothing, shoes, farm equipment, wagons, buggies, and more. Lunkley served on the school board and as undertaker on occasion. His store burned with the rest of that block on June 22, 1922. (CCC.)

"Park" is barely visible on the false front of this stable, and the second word is illegible. Both the men and the exact location are unidentified. A second stable, the livery and feed (built by Peter Smith and owned by Edward Evans), was located about three blocks east of Pacific (Park) Avenue. (CCC.)

One of three blacksmith shops was next to the Exchange Saloon on Third (162nd) Street. It had a series of owners before Charles (Charlie) Swanson became the blacksmith. Blacksmith Tobe Wyatt had a stagecoach relay station near the old Spanaway graveyard on 176th Street. The exact location of this competing smithy, which was owned by J.C. Pederson, is unknown. (CCC.)

Robert Creso Sr. recalls, "There were only a handful of automobiles—one-cylinder Benzes and Cadillacs, two-cylinder Fords." Nonetheless, these two unidentified Spanaway entrepreneurs invested in cutting-edge technology by opening an automobile-related business in Lake Park (Spanaway). The signs on the building advertise the tire brands Lee and Fisk. (CCC.)

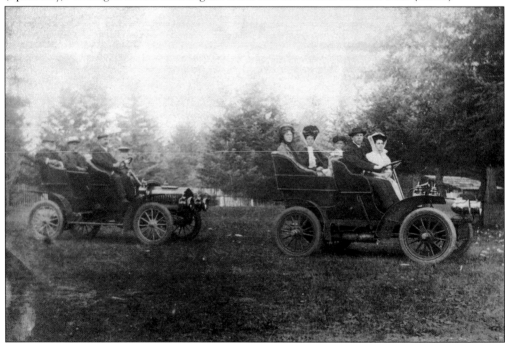

A Sunday drive was recreation for those who could afford cars. Robert Creso Sr. said, "We used to drive out to Grandpa Locke's farm. The ride would take about three hours. There was always a shotgun in the front between the front seat and the dashboard for protection as well as for game." (CCC.)

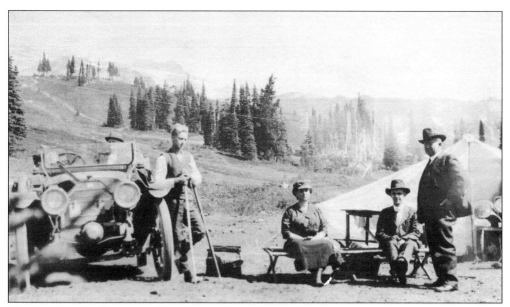

On their first family automobile trip to Mount Rainier from Spanaway, the Cresos drove from 8 a.m. to 7 p.m. before arriving at Reese's Camp on the mountain. "Mr. and Mrs. Reese had a kitchen and large dining room . . . and tents with a wooden floor, a white basin and a gallon pitcher of water, and Chic Sales." (Outhouses plastered with comedian Chic Sales's posters were called "Chic Sales," to the comedian's dismay.) (CCC.)

Peter Creso's real estate ventures were successful; indeed, he remodeled or built at least 15 Tacoma buildings in addition to Spanaway's Creso Hotel. This postcard shows his "flatiron" building, so named because its shape resembled a clothing iron, at 1102 Division Avenue in Tacoma. It was demolished in 1978. (CCC.)

Minna Creso and her children (on the left) visit an unidentified family in this photograph. With a career as an architect and draftsman for her husband's buildings, Minna was ahead of her time. Several 1917 *Tacoma Ledger* articles acknowledged Minna's talent. Robert Creso Sr. attended architect school in California and also worked in the family business. (CCC.)

Because she was a woman, Annie Eliza Reynolds was a doctor with few patients. She delivered babies for Lake Park wives and received a parcel of land on Spanaway Lake's shore as one of the payments. It was a time when a woman's place was still considered in the home, not in medicine, not in business, and especially not in politics. (SRL.)

First given the right to cast a ballot in 1833, Washington's female voters succeeded in local elections in closing "liquor hells." Letting women vote was seen as akin to enacting prohibition, and successful legal challenges revoked women's franchise in 1837. While decrying prim female morality that would deny thirsty gentleman the comfort of a drink, the *Territorial Dispatch* illogically called suffragettes "brazen harlots and open advocates of licentiousness." (WSHS EPH/324.623/Su9y/1909.)

THE SUFFRAGETTE.

You may think it fun, poor Cupid to snub,
 With the hand of a Suffragette,
But he's cunning and smart, aye, there's the rub
 Revenge is the trap he will set.

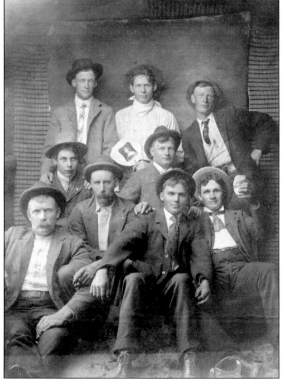

Washington's women finally won a permanent right to vote in 1910. They did vote "the whiskey ticket." A 1915 initiative forbade the manufacturing and selling of liquor except for medicinal purposes. The Exchange Saloon became a grocery and offered home delivery of "medicinal goods" made in stills on the island in Spanaway Lake. In this undated photograph Kenneth McKenzie Jr. (front row, right) imbibes with unidentified friends. (Wayne Cooke family.)

61

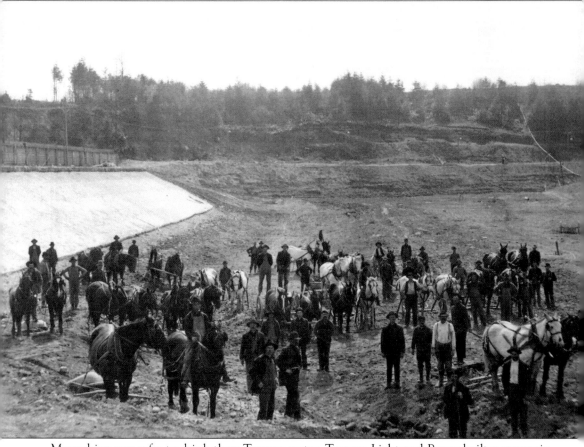

Moonshine was safer to drink than Tacoma water. Tacoma Light and Power built a reservoir, shown here in its early stages of construction, to hold the water it drew from Spanaway sources through a wooden flume. Birds, animals, and outhouses contaminated the water at its source and at the open reservoir. According to one report, cows frolicked in the flume. Weary of complaints about muddy, smelly, bad-tasting water and low profit, Philadelphia capitalist Charles B. Wright sold Tacoma Light and Power to Tacoma for $1.75 million in 1893. The taxpayers believed they had been rooked and that Wright's cronies on the city council had influenced a bad decision. The city sued. It recovered $125,000 and took Commercial Electric Light and Power Company, where Wright had hidden some assets. The City of Tacoma now owned Spanaway water rights, the original Henry de la Bushalier donation claim, and the Spanaway Lake resort. (TPL.)

Five

THE WAR YEARS

The two world wars had, perhaps, a more lasting impact on the Nisqually Plain, the Nisqually tribe, and Spanaway than on the rest of the country. Certainly, the original homesteaders paid a heavy price.

Washington's militia camped and trained on the prairie between American Lake and Spanaway Lake and leased part of John Wilson Roberts's land for maneuvers. Various military officials had recommended the area for a permanent Army post for the past 20 years. On December 2, 1916, with Europe at war, US Secretary of War Newton Baker signed a letter accepting a Tacoma delegation's offer to gift land "for purpose of maintaining thereon a permanent mobilization, training, and supply station."

Two days later, 150 businessmen presented a petition to the county commissioners asking for a special election that would authorize a 20-year bond issue of $2 million. The bond levy passed and would buy 108.2 square miles of private land on the Nisqually Prairie for the military camp. On April 6, 1917, the United States declared war, and 6,000 acres were immediately vacated to begin work on an Army encampment, with payment to the displaced landowners only a promise.

Named for early explorer Meriwether Lewis, the building of Camp Lewis immediately brought men, materiel, jobs, and money into Pierce County and a lasting economic benefit to the region and state. However, those whose land was taken did not fare as well.

The City of Tacoma and Pierce County saw dollar signs on the Nisqually Plain—an Army encampment there would bring in jobs and government money. To buy the land needed, the county had to raise $2 million in bonds. When the United States entered the war in Europe, the county hit voters with this 1917 advertisement. An Olympia paper called anyone opposed "red anarchists." (TPL A6059-1.)

Of the 29,194 ballots cast, a majority of 25,049 favored the bond issue; after all, those outside the area to be condemned for Camp Lewis expected a good financial return. The nay votes were largely cast by those who would lose their homes and livelihoods. The amount they were to be paid was not enough to buy farmland elsewhere. (Fort Lewis Museum.)

Karl Schwanz married Gustav Bresemann's niece Eliza. They raised their 14 children on a profitable hop farm southeast of Spanaway Lake. The hops were dried, treated with sulfur dioxide to prevent mold, and baled for market in the barn pictured here. The Schwanz farm was part of the acreage taken in 1917 to form Camp Lewis. (SHS.)

Wilhelmina and Amos Greenlaw's third daughter, Nettie, married Chistopher Turner c. 1897. The Turner's farm was one of dozens in Spanaway first condemned for Camp Lewis. The Turners relocated and built this house on Henry Berger Road (176th Street). The rest of the homesteaders southwest of Spanaway Lake lost their farms to an expansion of the camp in 1941. (SRL.)

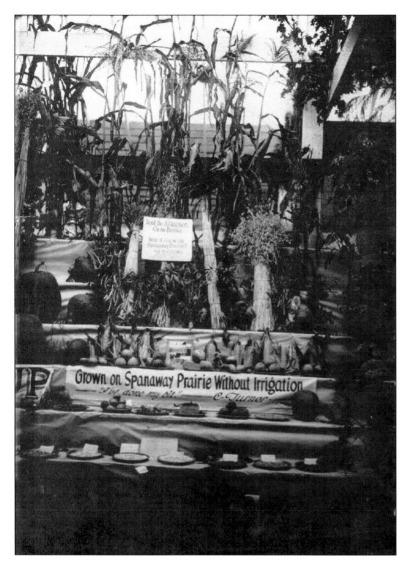

Christopher Turner objected to the price offered for his farm. He found a helpful provision in Washington State law: A lake or stream on the property added to its value, and if the land could produce crops without irrigation it was worth more. Turner proved he did dryland farming with this Puyallup Fair exhibit. (SHS.)

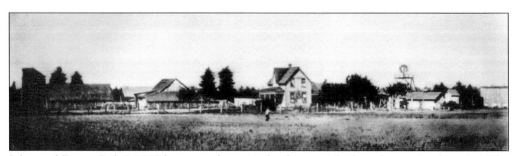

John and Emma Rohr's 1888 homestead was in the first round of condemnation lawsuits. The landowners valued their land at an average $47.54 per acre. The jury awarded $13.98 on average. Some who had paid $1.25 or $2.50 per acre under the Homestead Act received as little as $1 per acre. Like many others, the Rohrs salvaged their house and moved it into town. (SHS.)

This 1941 plat map shows the area in the immediate vicinity of Spanaway Lake given to the federal government for Camp Lewis in 1917 and in three later condemnations. East Airport Road was cut off where it entered military property and was routed around the south end of the lake to become Spanaway Loop Road. (SHS.)

A 1918 government survey for Camp Lewis noted "a beautiful little lake, Lake Spanaway, occurs near the east end of the Cantonment." Camp Lewis was up and running in 90 days. Four months later, the United States entered World War I on April 6, 1918. Soldiers found Spanaway Lake convenient for off-duty recreation. (WSA AR-07809001-ph001983.)

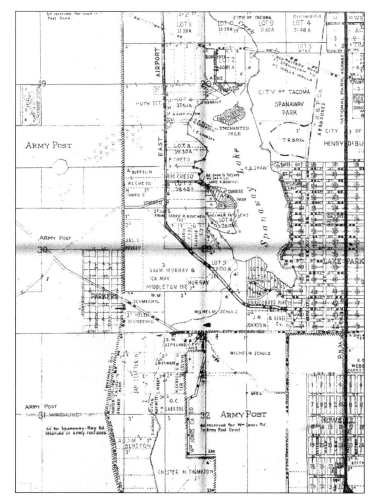

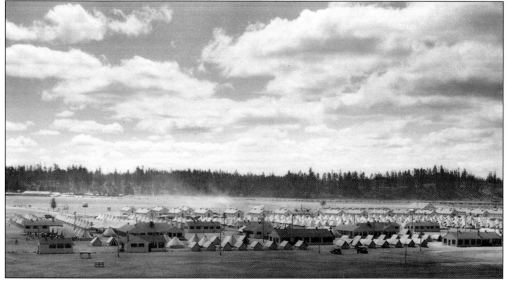

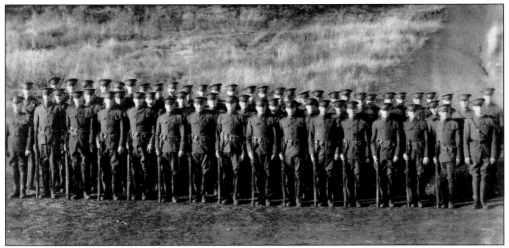

The negative of this World War I infantry unit photograph taken at Camp Lewis was found in Chester P. Creso's collection. The soldiers are unidentified, and Creso's grandchildren recall no one in the Locke, Creso, or Bresemann families who served. As recent German immigrants, they tried to remain neutral during the war. However, Creso and several other relatives were of draft age. (CCC.)

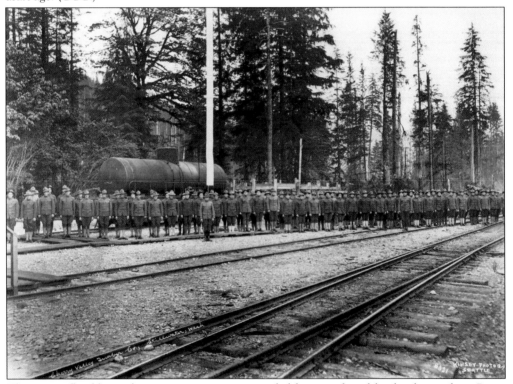

The strong, flexible northwest spruce trees were needed for aircraft and for the shipyards on Puget Sound, where many Spanaway citizens worked. The war created a worker shortage, giving loggers an opportunity to strike because of poor pay for dangerous work and abysmal logging camp living conditions. The Army drafted some lumber workers and formed a military logging unit, shown here c. 1917, to fill the gap. (Weyerhaeuser Company.)

George King was one of many local boys
who served in World War I. After the war
ended on November 11, 1918, King returned
home and married Lelah Allbert, who
worked for McKenzie's Grocery. The Kings
farmed for a time before buying a butcher
shop on Pacific (Park) Avenue. (Georgina
[King] Gonyeau.)

Because parents in the military wanted
to board their children at a safe place, the
Dominican Sisters did not have enough
space at their St. Edwards School for Boys
in Tacoma during the war. So, in 1919,
Mother Thomasina Buhlmeier (shown),
Mother de Chantal Brown, and Sister
Aloysia Burns raised funds to buy 100
acres in Spanaway for a boarding school.
(Sisters of Saint Dominic of Tacoma.)

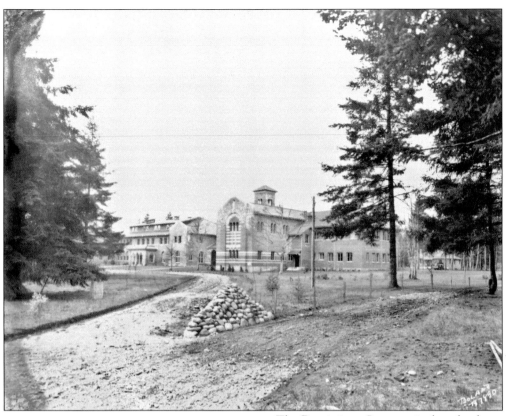

The Dominican Community bought the Annie Wright homestead on Military Road. Shown when it opened on September 4, 1923, Saint Edwards Hall was the first building for Marymount Military Academy. Sisters taught the school curriculum and Reserve Army officers provided military training. In 1972, the sisters dropped the military aspect because it conflicted with their values. The academy closed in 1976, but the convent remained. (TPL Boland-B7890.)

Although viewed by local boys as "the place all the rich kids went to school," Marymount taught boys of all faiths and socioeconomic backgrounds from places as far-flung as Mexico. Catholic instruction was required, so Jewish students went to synagogue on Saturdays and on Sundays attended chapel. Shown in 1940, from left to right, are Jim Cashion, unidentified, Robert Gilroy Jr., and Robert Gilroy Sr. (TPL D-9426-12.)

TACOMA MAILER'S UNION No. 54.
- 15th Annual Banquet -
The Firs - - - - April 25th 1932

In 1922, Irv Ball built the Firs two miles south of the Roy Y on National Park Highway. An inn, restaurant, and cabaret, it became as much of a regional draw as Spanaway Lake Park. The Firs catered to private parties like this celebration by the Tacoma Mailer's Union, which represented those who bundled and loaded newspapers. (TPL Richards-402-1.)

Shown here with her husband, Steven, Mary (Fowler) Pease was 10 years old when the chick incubator in McKenzie's feed store caught fire on June 22, 1922. A wisp of a girl, she carried 100-pound sacks of grain, weighing more than she did, away from the front of the burning store. The entire block of businesses between Third (162nd) and Fourth (163rd) Streets was lost. (Mary [Fowler] Pease.)

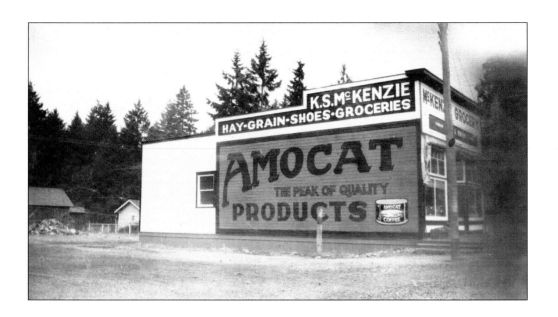

Kenneth McKenzie Sr.'s feed store and Lelah and George King's meat market were lost in the 1922 fire, along with Dan Lunkley's barn and other structures. Although two engine companies from Tacoma rushed to the scene, the fire trucks could not pump enough water 1,800 feet uphill from the lake to have any impact on the blaze. McKenzie rebuilt his grocery across from the Exchange Saloon on Third Street and Pacific (Park) Avenue. It also housed the post office, announced in small print on the store's window, below. George and Lelah King rebuilt their meat market next to McKenzie's. The buildings are still in use today, as is a house that the Kings built next to their meat market. (Both, Wayne Cooke family.)

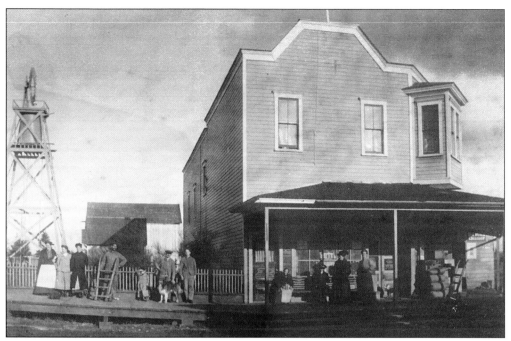

The people in this c. 1890 photograph of Frank A. Talley's home and store are not identified. Talley became chairman of an American Legion committee, lobbying in 1946 for a water district that could adequately supply water for a fire district approved the week before. Gustav Bresemann opposed a water district because it would levy $2.80 per front foot of property. The measure failed 147 to 134 votes. (CCC.)

Wars, fires, and economic downturns could not stop a bit of recreational travel for local families, including Sunday drives to view the scenery and to picnic on the prairie. From left to right, Kenneth McKenzie, his daughter Shirley, an unidentified man, and George King pose for a photograph beside their cars. (Wayne Cooke family.)

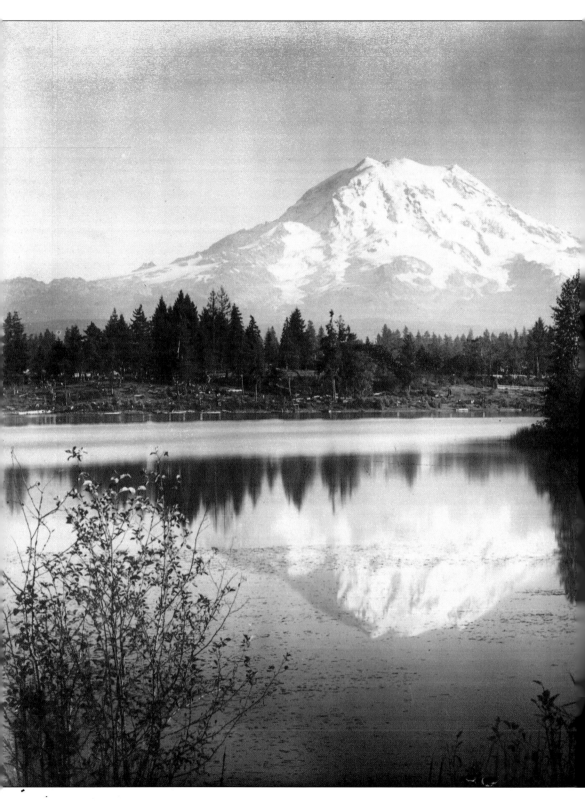

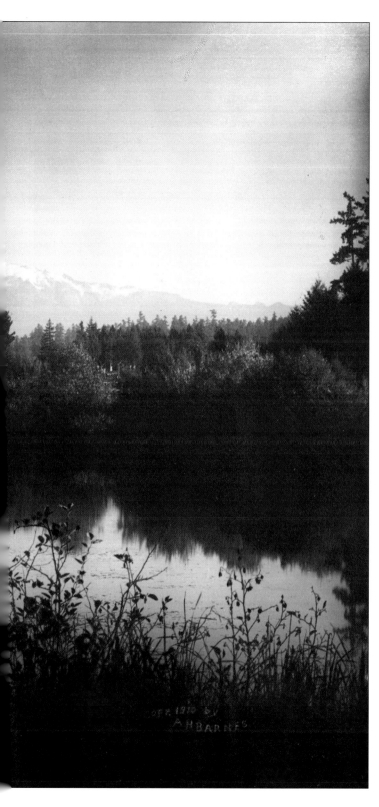

After World War I, tourist travel to Mount Rainier rebounded, bringing more en route trade to Spanaway businesses. Viewed from the Creso property on the west side of Spanaway Lake, Mount Rainier has been a popular subject for artists and photographers since Spanaway's early history. Tacoma city officials fought to have the mountain retain its Native American name, Tacoma. What better icon for the city? They had region-wide support, but the National Board on Geographical Names declared Mount Rainier the peak's official title in 1890. During the two world wars, a postcard of this image became popular for Fort Lewis soldiers to send home. This photograph by A.H. Barnes was taken around 1906. (UWH-SC, BAR 084.)

Pierce County's first speed limit was four miles per hour. Automobiles had to stop when a horse-drawn rig approached and wait until it had passed. The 10 miles per hour limit, posted behind the men seen here, was a testament to improved cars and fewer horses. From left to right are Gertrude and Bertha, their mother Bertha Bresemann, Minna and Peter Creso, and Gustav F. Bresemann. (CCC.)

The men in this c. 1937 photograph worked on roads between Spanaway and Roy as a Great Depression Work Progress Administration (WPA) project. All are unidentified except for Spanaway residents William (Bill) Wright, third from the right in the front row, and Charles Ervin Wright, fourth from the left in the back row. (Wright family.)

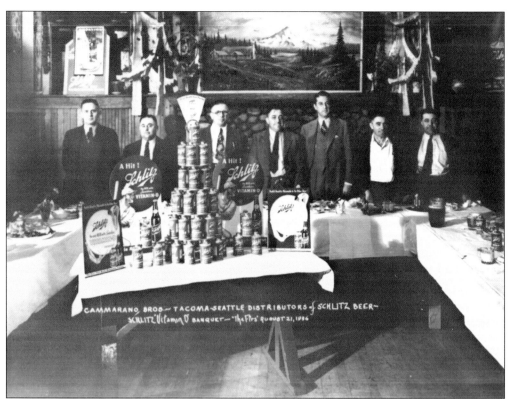

CAMMARANO, BROS — TACOMA-SEATTLE DISTRIBUTORS of SCHLITZ BEER— SCHLITZ Vitamin D BANQUET — 'The Firs' AUGUST 21, 1936

The federal government restricted the production of alcoholic beverages during World War I. After the war, brewing rebounded, and the Cammarano brothers— James, William, Phillip, and Edward—distributed beer to the Exchange Saloon, the Prairie Owl, the Firs, and other taverns in Spanaway. Hermann Fuchs worked for Cammarano for two years before buying McKenzie's Grocery. In the 1936 photograph above, Cammarano Distributors rolled out Schlitz Vitamin D beer in a banquet at the Firs in Spanaway. Schlitz brand was the first (and probably only) malt beverage to take marketing advantage of new vitamin discoveries with its Vitamin D–fortified beer. On the far right are Phillip and Edward Cammarano; the other men are not identified. (Above, TPL CAM-15; right, author collection.)

77

In 1927, Pierce County condemned another strip of homes along Spanaway's and Parkland's west sides. That land and Old Tacoma Airport became the Army air field. In 1938, the county condemned all land remaining between the Camp Lewis airfield and Military Road to create McChord Field. Spanaway Lake is at the upper right in this 1966 aerial view of the McChord Air Force Base runway. (TPL Richards-D149224-5.)

By 1939, Europe was at war. While some people of German descent tried to be neutral, others openly expressed their support for the German cause. The reason for this celebration at Spanaway's Prairie Owl Restaurant and Tavern in February 1939 was not recorded, but Pierce County sheriff John Bjorklund (seated at the lower right) wears a swastika, and Pierce County prosecutor Thor Tollefson (standing to Bjorklund's left) wears the German Cross. (TPL Richards-A7902-1.)

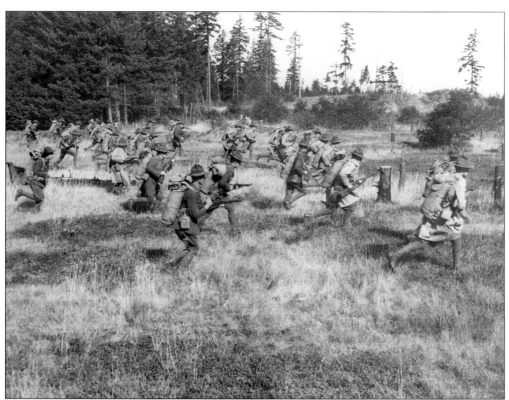

In 1941, the United States entered World War II. Pierce County condemned more land to the west and south of Spanaway to expand Camp Lewis to 70,000 acres. An Army commander noted, "Camp Lewis is. . . large enough to train infantry movements and provide room for the firing of the heaviest guns." (WSA AR-07809001-ph001973.)

Fort Lewis personnel skyrocketed from 7,000 in 1940 to 37,000 by 1941. McChord Field's military population nearly doubled from 4,000 to 7,400. Needless to say, World War II brought new custom to nearby watering holes. Al Zender, shown here on the porch of the Spanaway Exchange Tavern, served thirsty troops from 1943 to 1946. (Exchange Tavern.)

Alice M. Moorten, a Spanaway doll maker, posed with four of her cloth creations for a March 18, 1942, *Tacoma Times* article. Her contribution to the war effort was a bit unusual: at the request of the radio program "Hobby Lobby," her dolls were included in a nationwide raffle to raise money for a bomber. (TPL Richards D12611-4.)

During World War II, Harold LeMay drove a liberty bus that carried men and women from Spanaway and surrounding areas to work at the shipyards on Puget Sound. When World War II was over, Marymount Military Academy was LeMay's first commercial account for his garbage-hauling business. His Spanaway Refuse Company flourished, along with other businesses, in Spanaway's postwar economy. (LeMay Family Collection Foundation.)

Six

POSTWAR COMMERCE

The end of World War II in the mid-1940s ushered in a burgeoning postwar economy. War industries and military spending continued because of the threatening Cold War with Russia; therefore, Fort Lewis Army Post and McChord Air Force Base remained regional economic engines.

Many personnel discharged from Fort Lewis remained in this area, attracted by the mild climate, work or recreational opportunities, the beauty of the location, or personal ties created with local families. The GI Bill helped fund education in nearby technical schools and colleges, and housing support made it easy to buy a home.

Economic prosperity, pent-up demand for formerly scarce consumer goods, and easy credit followed the war. These factors, combined with Spanaway's convenient location to the ready market of the military bases, caused an explosion of small businesses.

Myron B. Kreidler shot most of this chapter's photographs in June 1946 for a June 27, 1946, pictorial edition of the regional newspaper *Prairie Pointer*. The paper's editor noted that about five percent of the businesses were missed. These included Irv's Exchange Tavern, Dick's Tavern, the Spanaway Café, the South End Trading Post, and five grocery stores: Community Food Store, Gibbons, McCann and Gillum, Rogers, and Renners.

The children of Myron and Enid Kreidler—Ruth Sather, Karol Cocchi, Burt Kreidler, and Marc Kreidler—made possible most of the following photographic record of post–World War II Spanaway; Kreidler's images had been lost in storage for 67 years.

VOL. 1, NO. 29 PARKLAND, WASHINGTON, THURSDAY, MARCH 28, 1946

Established in 1945 "to serve the South End" of Pierce County, the *Prairie Pointer* newspaper's territory included about 125 businesses and 15,000 residents. In 1946, publisher Elmer Beard put out a pictorial edition featuring local businesses. Today, Pacific Lutheran University's Mordvedt Library holds the only known copies of the *Prairie Pointer*. (Pacific Lutheran University Library.)

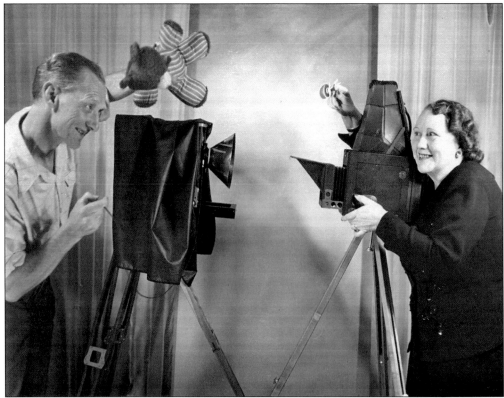

This photograph of Myron B. Kreidler and Doris Morrison appeared in the June 27, 1946, edition of the *Prairie Pointer*. Morrison specialized in theatrical portraits. Kreidler's first studio was in Harstad Hall on the Pacific Lutheran College campus (later in a nearby mall). Kreidler created a photographic record of industries and businesses south of Tacoma. (Kreidler family.)

82

An artist as well as a photographer, Myron Kreidler worked in a civilian camouflage unit to disguise key military installations with netting, plywood, chicken wire, and burlap during World War II. Shown in this photograph, his artwork included the 26-acre, three-dimensional neighborhood built on netting 40 feet above Boeing's Plant Two. (Boeing Company.)

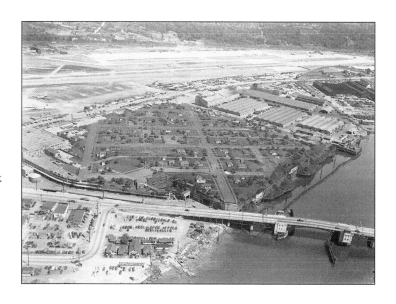

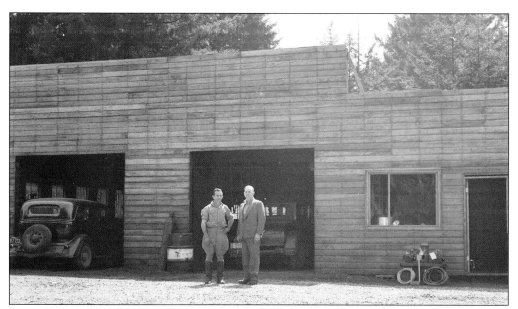

Located just south of the Roy Y on National Park Highway, Allison and Myer's Service repaired all makes of cars and trucks, converted coal-burning stoves to oil, and installed well pumps. It is unknown which person is Allison and which is Myer in this 1946 photograph. Note the jodhpurs and riding boots on the man to the left; although he serviced automobiles, he apparently preferred an older mode of transport. (Kreidler family.)

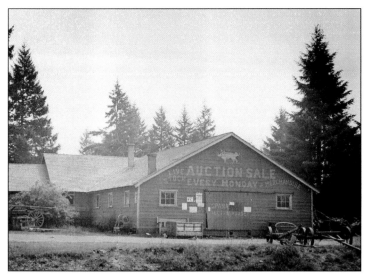

The owner of Spanaway Auction Barn, Phillip Zurfluh, opened every Monday to buy and sell just about every good imaginable. The auctions typically drew hundreds of people from the entire south Pierce County area. The Auction Barn survived well into the 1960s and was located just off National Park Highway (Pacific Avenue) north of Old Military Road. (Kreidler family.)

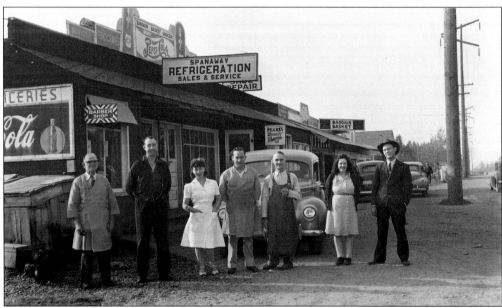

The Bargain Basket, on the right end of this strip of businesses, was a convenience store well into the 1960s. The Bargain Basket moved into its own brick building in 1947. Shown in front of their businesses, from left to right, are Bill Mayo, O.M. Johnson, Pearl Armon, Art Linton, Orville ? (Linton's employee), Stella Gillum (employee of E.M. McCann), and E.M. McCann, owner of the Bargain Basket. (Kreidler family.)

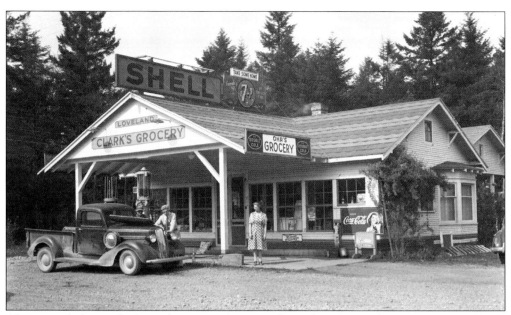

Clarence Clark was discharged in December 1945 from the US Merchant Marine. Originally from California, Clark and his wife, Martha, moved to Loveland and bought Ohr's Grocery. The Clark's home is behind the station. They sold groceries, meat, ice cream, soft drinks, and Shell gasoline and oil products. (Kreidler family.)

Neil Thompson bought the Clover Creek Market in October 1945. The market offered groceries, meats, drugs, and sundries. The large addition shown under construction to the right of the existing store in this June 1946 photograph would allow Thompson to expand his product line. He had one employee, Robert Johnson. (Kreidler family.)

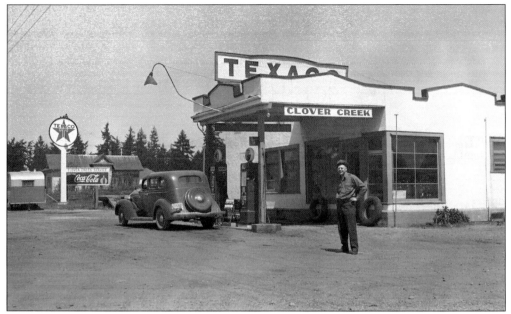

Owner John E. Jacobson had a complete line of automobile accessories in addition to Texaco gasoline and oil products. Jacobson was in the process of installing a lubrication bay to expand his service when this photograph was taken in 1946. The service station was located on Old Military Road near Knoble Road, now Thirty-eighth Avenue East. (Kreidler family.)

This 1946 photograph shows the newly remodeled interior of the Craney Crow Restaurant. Owner Donna Thompson specialized in private parties. Bernice Shephard and Fern Guinn worked there. Craney Crow was located on National Park Highway near the Roy Y. (The highway forks a mile south of Spanaway Lake to head toward Mount Rainier on the left and to Roy on the right.) (Kreidler family.)

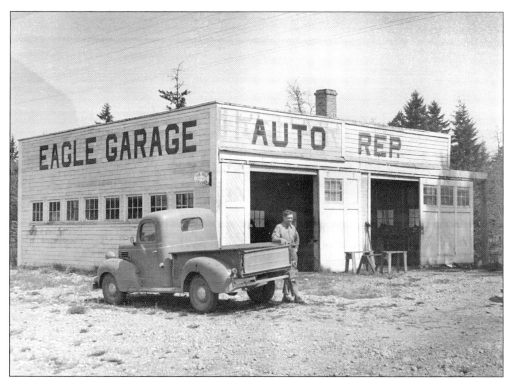

John Ockfen Jr., a machinist and welder, bought Eagle Garage for his own use, but word got around about his mechanic skill. He accommodated those seeking his help, repairing their vehicles evenings and weekends for barter or the cost of parts. The Ockfen home and Eagle Garage were on National Park Highway near 213th Street. (Kreidler family.)

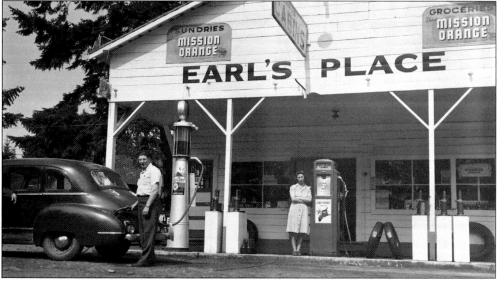

Owner Earl Thomas fills a gas tank at Earl's Place in 1946. Mrs. Thomas is seen leaning against the Fire Chief gasoline pump. Earl's Place sold groceries, meats, ice cream, automobile accessories and tires, and Texaco Sky Chief gasoline and oil. The sign "Earl's Cabins" advertised the living facilities behind the station, which the Thomases offered for transients. (Kreidler family.)

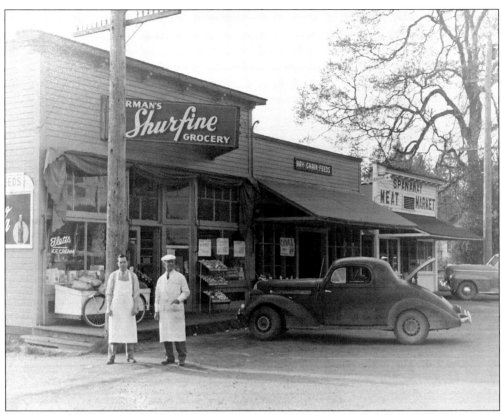

Pictured at left, Herman Fuchs bought McKenzie's Market at 162nd Street and Park Avenue in December 1937 "for young love," he said; he married a Spanaway woman and moved near Spanaway Lake. Fuchs built a feed store between his grocery and George King's meat market, pictured at the right in 1946. After King sold his shop to Bob Carlson, who Fuchs said "was not a good butcher," Fuchs squeezed in a small meat case and hired Mr. Stedfelt, "who knew beef." Shown below, Stedfelt serves unidentified customers. The post office was in a corner of Fuchs's store in 1946, and Mrs. Phipps was postmistress. Fuchs helped start the first Spanaway fire station, took fire calls at the store, and rang the bell to call in volunteer firemen. Cecilia Niesen, Dorothy Righetti, and Sammy Crisman worked for Fuchs. (Kreidler family.)

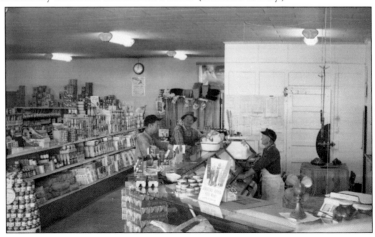

Helen Hermanson, the co-owner and manager of Joe's Place, takes a dinner order from unidentified diners in the 1946 photograph above. In the photograph below, owners Joe and Helen Hermanson stand behind the bar, which was located in the corner of Joe's Place. Seated at the bar, from left to right, are an unidentified customer and brothers George and Herman Hermanson, who together owned a slaughterhouse in Spanaway and later bought Joe's Place from their parents. Originally called the Prairie Owl, Joe's Place changed owners several times before becoming the Gold Dust Saloon in the 1960s and TJ's Tavern in the 1990s. Joe's was on the northeast corner of National Park Highway and Shepherd-Simons Road, now 166th Street. (John Todd.)

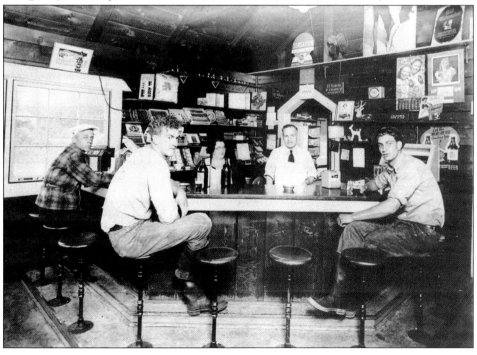

By 1946, Irv Ball had sold the Firs to Emma King, shown here preparing tables for a banquet. The banquet hall was on National Park Highway two miles past the Roy Y. Used primarily for private parties and noted for its family-style chicken dinners, the Firs burned in 1974 and was not rebuilt. Lloyd Elton's Orchestra provided entertainment in 1946. (Kreidler family.)

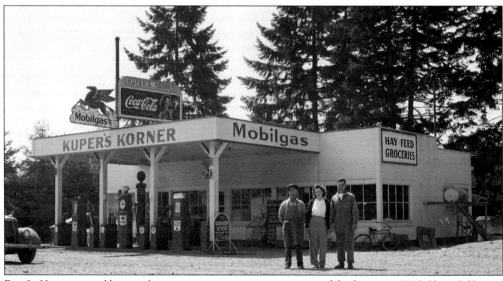

Ben L. Kuper started his combination service station, grocery, and feed store in 1940. Kuper's Korner offered a complete line of groceries, hay, feed, hardware, gasoline, and oil. Shown left to right in 1946 are Kuper, employee Doris Crim, and Kuper's son Earl. Kuper also employed Dorothy Rich. The store was at the intersection of Mountain Highway and Twenty-second Avenue. (Kreidler family.)

Shown in this photograph, Pete Boone (left) and Jim Lowerey opened their Lobo Service station on National Park Highway between the Spanaway Lumber Company and the Roy Y in 1946. Lobo's sold automobile accessories and Clipper gasoline and oil products. The Lobo's petroleum provider named his company "Clipper" because the Pan Am Clipper airplane so impressed him. (Kreidler family.)

Hugo Loveland built Loveland Garage on Mountain Highway and Twenty-second Avenue in 1945. Loveland's garage provided overhauling, body and frame work, welding, engine repair, and auto glass installation. Shown, from left to right, are Bob Ettlin (customer), Frank Wray (employee), Jack Rankin (employee), Hugo Loveland, and Jack Burnside (night watchman) and his dog King. (Kreidler family.)

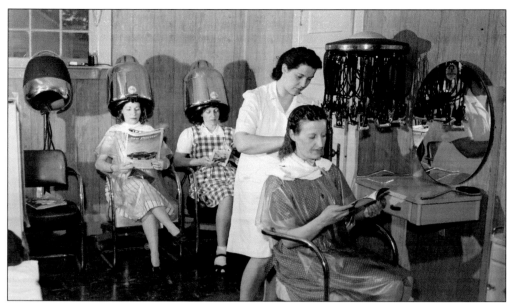

In this June 1946 photograph, Margaret M. Newman puts her eight years of experience as a beautician to work with three unidentified customers. Margaret opened her shop in 1942 on Mountain Highway in the Second (161st) Street block. With Pearl's as the only other beauty shop in the area, both were kept busy serving the burgeoning population. (Kreidler family.)

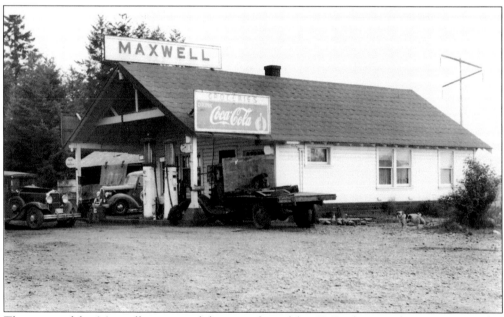

The owner of this Maxwell station and the exact date of this 1940s photograph were not recorded by photographer Chapin Bowen. The Maxwell station was located at Route 1, Box 431, Spanaway, and sold Mobil gasoline and oil. This photograph was likely commissioned by the Mobil Oil Company. (TPL, 114-177.)

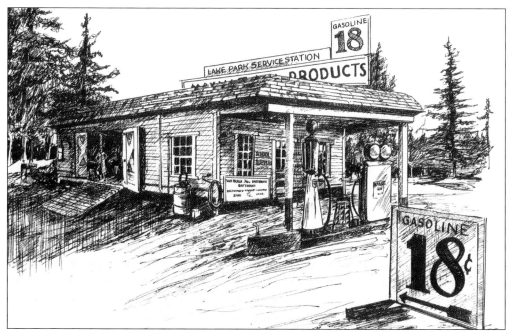

In 1938, Chester (Chet) Modahl bought the Lake Park Service Station, shown in this drawing by Nancy (Modahl) Bica. Modahl remodeled it to accommodate a general store and later removed the gas pumps and converted the building to an auto parts store. Automobile batteries were rationed during the war, so rebuilding them was one of the services Modahl provided. (Dennis Modahl.)

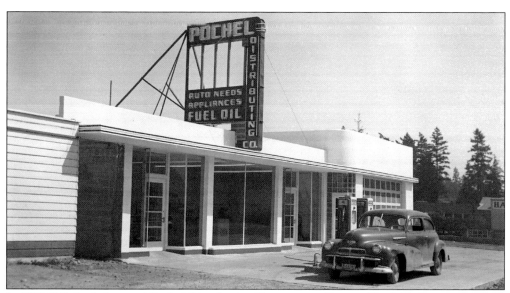

In 1939, R.E. Pochel started Pochel Distributing Company on National Park Highway and today's 140th Street. Pochel's distributes Mobil petroleum products and sells service station equipment, mechanic's tools, and home appliances. Pochel's 15 employees in 1946 were Harry Beer, Carl Bennett, Emmett Boyd, Wiggam Copley, Ed George, James Gray, Henry Hetle, Fred Johnson, R.N. Johnson, Walter Malmgren, Albert Riley, Ralph Riley, Newell Skinner, Ed Thornhill, and Wiggam Copley. (Kreidler family.)

This aerial view shows the airfield where Wayne R. Russell established his flight school in February 1946. The airfield was located 1.5 miles east of National Park Highway on the southeast corner of Rademaker Road (Twenty-second Avenue) and Old Military Road. Three of Russell's pilots were Norman Hondle, Wayne Johnson, and Val Halsey. (Kreidler family.)

Gene Russell was trained in radio mechanics during his service in World War II, where his responsibility was installing, maintaining, and repairing Army Air Corps ground and airborne communications equipment. When he returned to Spanaway, he started a business in his field of expertise. This June 1946 photograph shows Russell busy at his shop repairing a customer's radio. (Kreidler family.)

Roy Lape and Bud Moore offered student instruction, plane rentals, charter flights, and sightseeing rides at the Spanaway Aircraft Company, established in 1946. This photograph shows Moore and pilot Roy Wuellner on the field located at the intersection of National Park Highway and the Roy Y. Lape's son Albert was also a pilot and helped with the business. (Kreidler family.)

Started by Merle Handy Sr. in 1915, Spanaway Auto Company garage and service station served customers for over 50 years before the Handys retired. Les Lindbeck, not shown, worked with Merle Handy Jr., seen here fueling a car in 1946 in front of their newly rebuilt garage on the northwest corner of National Park Highway and Fourth Street (now 162nd Street). (Kreidler family.)

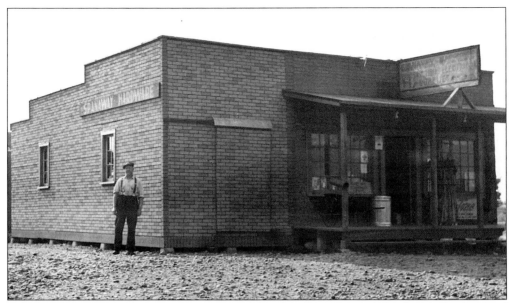

Shown in front of his store in this June 1946 photograph, John P. Rohr sold hardware, plumbing and electrical supplies, roofing materials, and dishes, among other goods, at the Spanaway Hardware Company. Rohr and his wife had owned the business since 1940. Mrs. Rohr and her son Leslie helped with the business. (Kreidler family.)

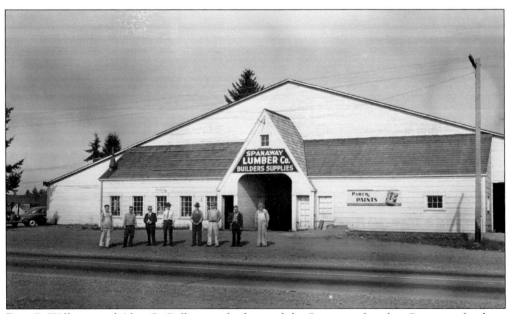

Don C. Williams and Alan G. Culbertson had owned the Spanaway Lumber Company for three years when this 1946 photograph was taken. In addition to builders' supplies, the building housed a cabinet shop, a fuel company, and a truck-weighing scale. Shown from left to right are Walter Christian, Leo Craney, H.W. Culbertson, Alan Culbertson, John Fleming, Don Williams, Roy King, and Alex Carlson. (Kreidler family.)

The original Spanaway Meat Market was sold by Bill Schwanz to George King in the 1910s. Located in a block of businesses south of Fourth (162nd) Street, King's store, along with the entire block, burned in 1922. King rebuilt his store, shown in this 1946 photograph, one block north of the original next to McKenzie's grocery and across from the Spanaway Exchange Tavern. (Kreidler family.)

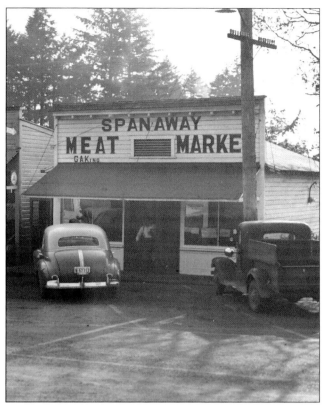

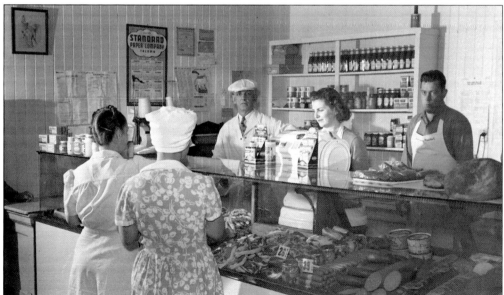

Spanaway Meat Market owner George King is on the left behind the counter. King's wife, Lelah (Allbert) King, and employee D. Justice help two unidentified customers. King would tease the neighborhood kids by locking them in the cooler for a minute. In 1962, the Kings retired and sold the meat market to the two Carlson brothers, who stayed in business only 18 months. (Kreidler family.)

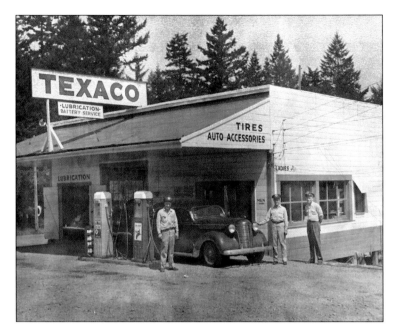

Pictured in this June 1946 photograph, from left to right, are Len O'Hern (Spanaway Texaco manager), Bob McGlothlin (employee), and Larry Warner (employee). O'Hern assumed management of the station after being discharged from his service during World War II in the Navy. The station was at the intersection of National Park Highway and today's 159th Street. (Kreidler family.)

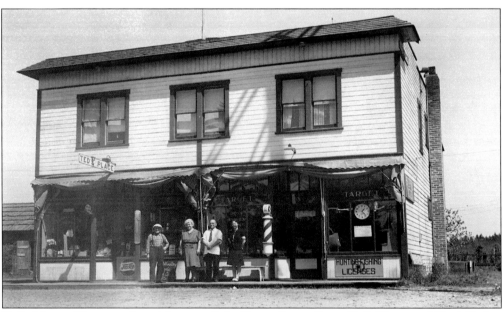

Called "one of Spanaway's social centers," the Target Sports Store, Ted's Place, and Don's Barber Shop offered one-stop shopping. Customers could buy sports equipment and supplies at the Target, stop in for a haircut or shave at Don's, and pick up a variety of goods at Ted's Place. Shown in this 1946 photograph, from left to right, are Pedro Hunt, J.E. Wormald, Don McClellan, and A.H. Wormald. (Kreidler family.)

In 1939, the Esarey brothers built Woody's Market on Mountain Highway and today's 181st Street. Howard, shown here, resumed management on his return from the Merchant Marines in late 1945. Woody's had a full line of groceries, a meat counter, and sold Veltex products. It is unknown which of the employees in this photograph is Ella Esarey and which is Laura Louden. Flossie Zurfluh also worked at Woody's. (Kreidler family.)

By 1946, there were 20 places to fuel up in the immediate vicinity, including at least one profitable pump at even grocery and hardware stores. In July 1947, Cliff Anderson added more competition when he opened this Chevron station on National Park Highway and today's 176th Street. In addition to Chevron gasoline and products, he had a bay for automobile repair. (TPL D28626-6.)

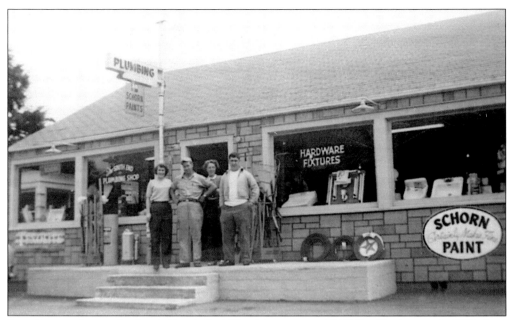

Standing on the porch of their South End Plumbing store at 18707 Pacific Avenue in 1951, from left to right, are Rose Marie Salter (Bill and Dorothy Righetti's daughter), William "Bill" Righetti, Dorothy Righetti (Bill's wife), and Joe Righetti (Bill's brother). Bill and Dorothy Righetti first bought the business c. 1948 and later remodeled and expanded to become South End Hardware. (Brian Stead.)

The staff of the *Prairie Pointer* newspaper in 1946 were, from left to right, Elmer Beard, Ed Knutson, Joe Ghesquiere, Lorna Rogers (associate editor), Marilyn Pflueger (office assistant), and Bernice Eklund (editor). They are shown in front of the Beard Printing Company office, which was located in the chapel basement at Pacific Lutheran College in Parkland. Although the *Prairie Pointer* ceased publication in 1949, its name still exists today as the title of the Spanaway Historical Society newsletter. (Kreidler family.)

Seven

REGIONAL TREASURE

Since 1890, Spanaway Lake has been a recreation mecca for Tacomans and tourists. Tacoma owned the land by 1899 and placed it under the control of its Metropolitan Park District in 1905. From custodians to trolley drivers, Spanaway residents managed and maintained the railway and park—Spanaway labored so Tacoma could play. Still, Tacoma's Metropolitan board complained, "The manner in which Spanaway Park was acquired makes it possible for the large population living in the vicinity to enjoy its facilities without in any way contributing by taxation to its operation, maintenance, and improvement."

Metro tried to sell the park to the state in 1950. Pierce County and Spanaway residents had paid their share of a state driver license fee dedicated to parks. The state park system had a $2-million budget that year and gave $1 million to Seattle; it returned zero to Tacoma and Pierce County. "Tacoma's Metropolitan Park Board seems to be the poor relation of the park systems," the Metro board complained. No agreement was reached. In 1959, short of money, Metro turned Spanaway Park over to Pierce County. Pierce County also took back the section of park land known locally as Bresemann Park. The board eliminated Bresemann's concessions and began a major development of the land.

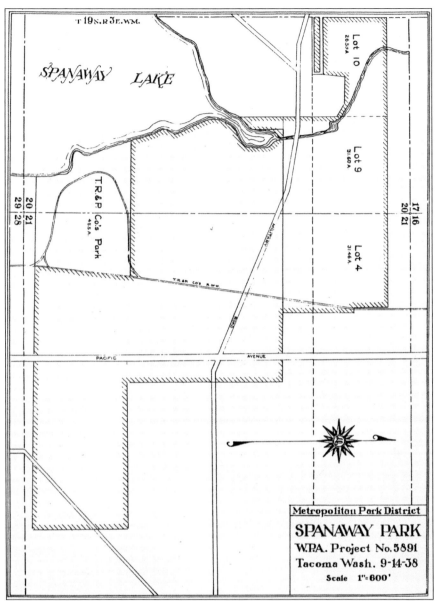

In December 1888, Tacoma Light and Water paid Gustav F. Bresemann $20,000 for water rights and lots 4, 9, and 10 on the north boundary of the Henry de la Bushalier donation claim. In January 1889, the company gave $2,100 for a quitclaim deed from real estate developer Stuart Rice for "all of the donation land claim of Henry de la Bushalier." Bresemann and Rice had little choice; the company condemned the land and water rights of those unwilling to sell for its flume line to Tacoma. Tacoma Light and Water changed hands and names several times. By 1895, the Tacoma Railway and Power Company held the Spanaway Lake property and the rail line to Lake Park (Spanaway). On February 8, 1899, Tacoma Railway and Power Company transferred the company's plant equipment, all the Spanaway land, and its flume line right-of-way to the City of Tacoma. Except for 45.5 acres labeled "T.R.&P. Co.'s Park" on this map, the city council deemed the Spanaway acreage a park and transferred control to the Metropolitan Park Board in 1905. (Metro Parks.)

This photograph of Gustav G. Bresemann beside Spanaway Lake appeared with the headline "Gus Bresemann newly named manager of Spanaway Lake Park by the Tacoma Railway and Power Company." The company had asked the Metropolitan Park Board to resume control over 45.5 acres on which Bresemann had a lease. Bresemann agreed to release his lease, provided he continued to manage the park and could charge for concessions. (TPL BSM.)

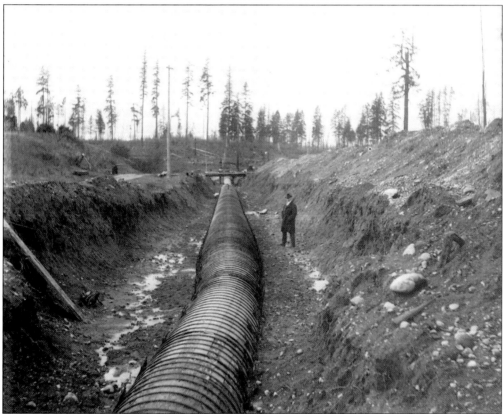

In 1918, Tacoma wanted to install an underground pipeline from Spanaway Lake to the city across its abandoned flume line easement. Because the pipeline installation was too destructive, as shown in this photograph, the Metropolitan Park Board would not allow it. In retaliation, Tacoma passed an ordinance to undo the park designation and threatened to sell the property. The park board sued and won, thereby saving Spanaway Park. (TPL.)

Saturday, Sunday, Monday and Tuesday

SPANAWAY PARK!

For the Next 4 Days

Commencing TO-DAY August 2nd 1902.

8th BATTERY U. S. A.

Consisting of

105 MEN 125 HORSES 6 GUNS

With

CAPTAIN HENLY.

Commanding

Will be in Camp at Spanaway Park Saturday, Sunday, Monday and Tuesday. This Troop has been in Service in Cuba and has lately returned from the Philippines where they have been in Service 3 Years.

This is one of the finest Troops in the U. S.

Be sure and see them Drill.

CARS EVERY 40 MINUTES

Dancing every Evening

MUSIC BY ADLERS BAND

For many years, Spanaway's park had a campground at one end. After its return from action in Cuba and the Philippines in 1902, the 8th Battery artillery unit camped in Spanaway Park and held a four-day celebration that was open to the public. "Cars every forty minutes" referred to streetcar access to the park and the activities. (WSHS 1903.1.553.)

In 1902, the Laundrymens Picnic, a Chinese celebration, was held at Spanaway Park. This flyer advertised, "The laundrymen of Tacoma will throw out their Wash Water, will turn over their Wash Tubs, throw their Flat Irons in the Back Yard and retire to Spanaway Park Where the Wash Boys will proceed to White Wash the Street Car Boys in a Game of Base Ball for $10." (WHSH 1903.1.149.)

The variety of terrain, beach, and concessions at Spanaway Park lent itself to "sports of all kinds," as advertised in this 1903 event held by the Butchers union. In addition to swimming and donkey and pony races, "Commodore Sullivan of the Waterfront, will jump through a ring of bologna without breaking the skin." The meat cutters' donkey race prize was a gold-mounted meat auger. (WHSH 1903.1.525.)

BUTCHERS
BARBECUE AND PICNIC
SPANAWAY PARK

THURSDAY, AUG. 13, 1903

SPORTS OF ALL KINDS

Consisting of Ball Game, Tug of War, Ladies and Girls Races, Running and Swimming Races, Pony and Donkey Races, Baby Show, Weinerwurst Eating Contest, Etc. Etc.
Meat Cutters Donkey Race--Prize, a gold-mounted meat Auger.
Striking Machine, open to all, Prize $5.

COMMODORE SULLIVAN

Of the Waterfront, will jump through a ring of bologna without breaking the skin at 5:30

GRAND BALL IN THE EVENING

Prize Waltzes and Grand Cake Waltz. Dancing in the afternoon free.
Dancing in the evening--Gents 25c, Ladies free.

Colonel Johnson of New Orleans, and Sir Jackson of Mobile, assisted by Chef Davis, will have charge of the Barbecue.

Everybody Welcome. No charge for the Barbecue.

Copeland, Printer, 111 Tenth St.

WASHINGTON STATE HISTORICAL SOCIETY

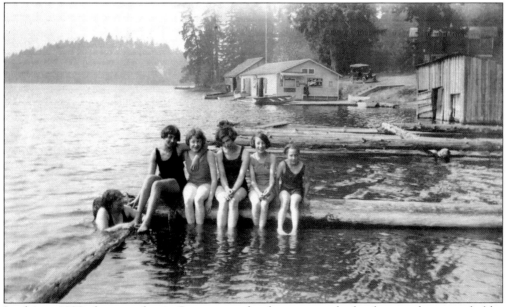

In this c. 1920 photograph, six Spanaway schoolmates pose by log booms that once held a houseboat, which was moved to Pacific (Park) Avenue and remodeled as the Creso Hotel. From left to right are Kathleen Frost, Dorothy Fowler, Grace Sutloff, Alice McLean, Mary Fowler, and Kathryn Fowler. In the background, two boys get into a canoe. The man who rents the canoes sits under a sign advertising Velvet Ice Cream. (Dorothy [Fowler] Fitts.)

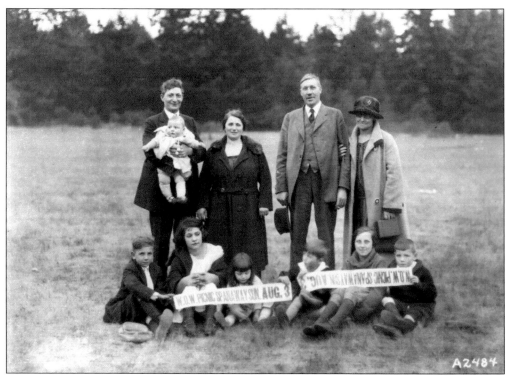

Two unidentified families hold banners advertising a Woodmen of the World picnic at Spanaway Lake on August 3, 1924. The fraternal order provides insurance and financial support to its members, which included several Spanaway residents. It also funds and conducts volunteer, patriotic, and charitable activities. The organization's name came from a sermon about pioneer woodmen clearing the forest to provide for their families. (TPL A2484-1.)

WASHINGTON STATE CHAMPIONSHIP

Walkathon Contest

ADDED
ATTRACTION
MORO
"THE MAN THEY
CANNOT KILL"

Frozen in a Cake of Ice Twice Daily
Other Acts

SPANAWAY PAVILION

Spanaway Lake on Mountain Highway—NOW!

This May 30, 1931, advertisement in the *Tacoma Times* had an "added attraction, Moro the Man They Cannot Kill, Frozen in a Cake of Ice Twice Daily." Moro sandwiched himself between two hollowed-out ice blocks and remained there for 30 minutes (supposedly, he could hold his breath that long). The "Walkathon" was a deceptive advertisement for a dance marathon, an activity that public officials frowned upon.

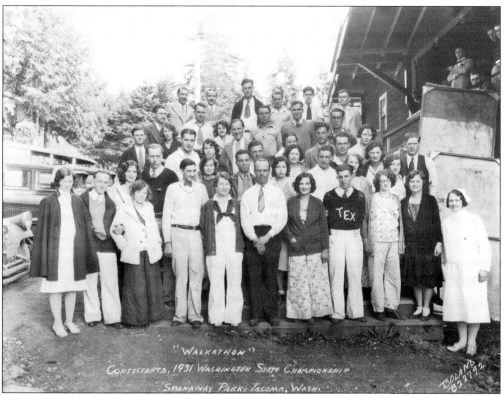

Entrants to the May 25, 1931, Washington State Walkathon Championship at the Spanaway dance pavilion pose with two nurses—a wise precaution—before the dance marathon began. On May 29, the promoter, the merchant who provided food for the contestants, and concession manager Gustav G. Bresemann were arrested for "unlawfully conducting an immoral, indecent, and obscene dance." Charges against Bresemann were dismissed. (WSHS 1957.64.B23792.)

In 1932, a crowd turned out for the first Liberty Party parade and picnic at Spanaway Park. Founded in 1932, the Liberty Party supported W.H. "Coin" Harvey, a wealthy businessman who ran for president on a platform of monetary reform. The party merged that same year with the Jobless Party; the deepening 1930s depression generated support for communism. (TPL B24710.)

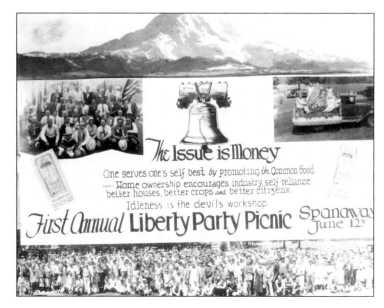

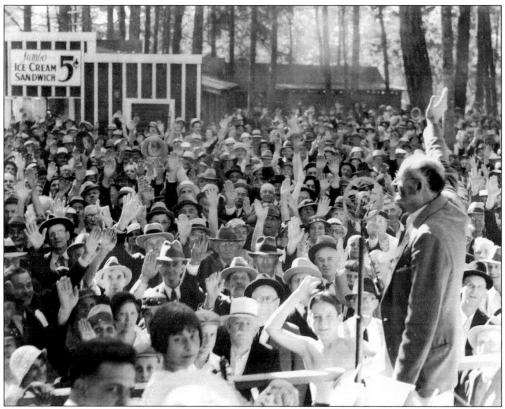

On Labor Day in 1935, an estimated 10,000 people came to a Townsend rally at Spanaway Park. Appalled at seeing elderly women digging through dumpsters behind his house, Dr. Francis Townsend proposed an Old Age Revolving Pension Plan paid for by a federal sales tax. As this turnout shows, it was a hugely popular proposal and resulted in the Social Security Act. (TPL D1703-5.)

Mining Opportunity For City Park Board

Valuable Titanium-Iron Oxide Deposit Found in Spanaway Park Well Dug for Tacoma Girl Scout Camp

In January 1933, Spanaway Park revealed true treasure when a peculiar mixture of red and black sand was found 130 feet deep while drilling on the former Bresemann lot next to National Park Highway. The sand proved to be ilmenite, or iron titanium oxide, the ore for pricey titanium. The park board did not go into the mining business to retrieve the ore. (*Tacoma Daily Ledger.*)

Tacoma Central Labor Council's 1933 Labor Day celebration featured Congressman Wesley Lloyd and Assistant US Attorney Joseph Mallery. Events included a baseball game between the Seattle and Tacoma fire departments and sack, potato, wheelbarrow, and three-legged races for the kids. Among adult competitions were a husband-calling contest and fat man's and fat woman's races. (UWL-SC PNW01102.)

Labor Day Picnic
PROGRAM
Spanaway Park

Sponsored by Tacoma Central Labor Council

Speakers

Senator Homer T. Bone
Congressman Wesley L. Lloyd
Assistant U. S. Attorney Jos. Mallery
James A. Taylor, President State Federation of Labor

Speaking Begins at 2:00 p.m.

Sports Program Begins at 10:30 a.m.
Baseball Game Begins at 12:00 noon

Air Circus, Swimming, Dancing, Boating
Thruout the Day

Hamburgers and Hot Dogs on the Grounds at 5c

A new dance hall, shown in this sketch by A. Ramirez, was built on the east shore of Spanaway Lake in 1937. Headlined in the *Tacoma News Tribune* as "the state's biggest open air dancing pavilion," the permit issued by the Metropolitan Park Board to park manager L. Zellinsky was under the condition the immoral "bunny hug", "turkey trot," "Texas Tommies" and other "animal" and "ragtime" dances not be allowed. (SHS.)

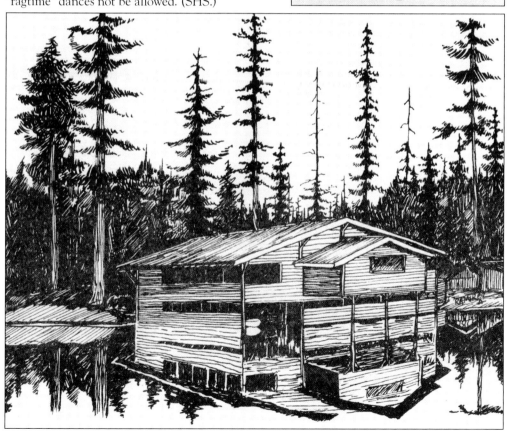

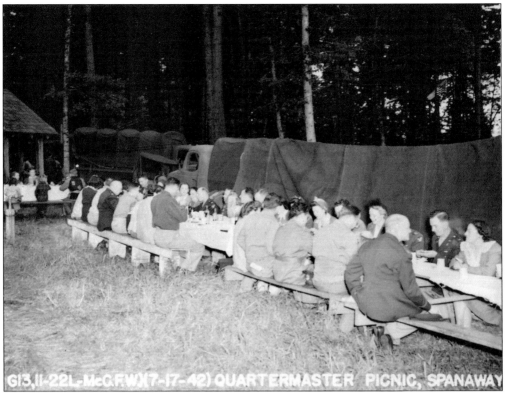

Despite the pressures of World War II, Fort Lewis Quartermaster Corps personnel and their families took time out for a picnic at Spanaway Park on July 17, 1942. Many of the men were in uniform. The children are seated at a separate picnic table on the left. The food was served buffet style from the back of the two military trucks. (WSHS 2008.6.13.1.)

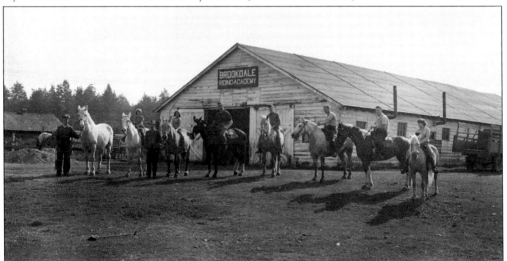

Brookdale Riding Academy had a concession to provide rental horses and lessons in horsemanship at Spanaway Park in the 1940s. This 1946 photograph by Myron Kreidler shows several unidentified children and adults with their steeds in front of the riding academy's stable west of Spanaway Lake. (Kreidler family.)

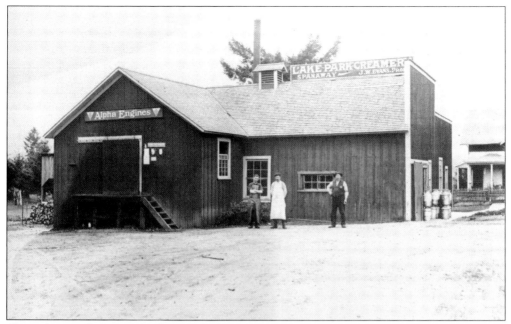

Shown here with owners Ike (left) and John Evans (right) and butter maker Mr. Benidickson, the Lake Park Creamery inadvertently helped to make fishing derbies popular at the lake. The creamery's butter churn drained through a pipeline into the lake, and the buttermilk outflow attracted fish. In 1947, Roy Waite made the *Prairie Pointer* news with a 24-inch, 6.5-pound trout. (SHS.)

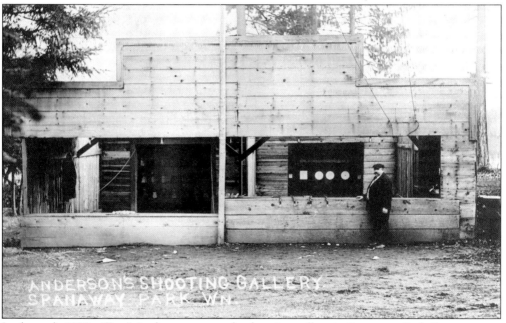

In the early 1900s, "Fats" Anderson operated a shooting gallery in Spanaway Park. Because guns were a necessary farm implement, proper handling of them was taught in Scouts and in schools. In 1958, a rifle range was also set up in the park. The Spanaway Sniper Junior Rifle Club members practiced, held competitions, and gave demonstrations of skill at Spanaway Park's rifle range. (WSHS 1994.36.3.)

In 1959, Pierce County acquired Spanaway Park from the Metropolitan Parks District. It first leased pieces of the "L" of the Bushalier donation claim east of Pacific Avenue to private businesses for $1 annually. Philip Zurfluh rented a piece for his auction barn. In the mid-1950s, the Parkland Roundup was held on the undeveloped park area west of Pacific Avenue, and Spanaway Fire Department's Santa Claus parachuted from a helicopter there in 1959. Pierce County eventually sold the east L and part of the original Bresemann claim north of Military Road. With those funds, a $68,300 federal grant, and a $1.5 million bond issue, the county paid for park improvements in 1967. The west section north of Military Road, containing Morey (Spanaway) Creek and the Bresemann millpond, was left in its natural state as Bresemann Forest.

Gustav G. Bresemann may have bought the 45.5 acres of park he had first managed for the Tacoma Railway and Power Company, or he at least had a long-term lease. He and his family lived in the boathouse seen in the upper left of this photograph. In November 1960, Bresemann returned his concessions and land to the parks department for $150,000. (Wayne Cooke family.)

On May 22, 1960, students from Pacific Lutheran University celebrated the end of the semester with a basket social on the play field in Spanaway Park. The occasion included a costume skit and an auction. In this photograph, gift-wrapped items for the auction are on the table in front of the derby-attired auctioneer. (TPL D126647-380.)

Until the late 1960s, a bridge crossed a gully on the heavily wooded east side of the park. Pierce County Parks developed this area south of Military Road, from the original railway and flume line right-of-way to Pacific Avenue, into an 18-hole, championship golf course that opened in 1967. (SHS.)

Wayne Cooke, a member of Tacoma Mountain Rescue, lamented with fellow climbers that "Spanaway had no hills" to teach mountaineering safety techniques to his Explorer Post, shown here at Mount Rainier. "Just pile up 10 feet of rocks," someone quipped. Cooke did just that, entirely with donations, volunteer labor, and granite blasted and hauled by the Army. (Ron Servine.)

Cooke got permission to build a climbing rock and "went begging hat in hand" for donations to cover costs. To lift and stack the rock, Cooke mounted an old pulley on a rotating arm at the top of a telephone pole in the center of the base. Billy Bowlding, pictured here with Cooke, handled volunteer recruitment telephone calls. (Wayne Cooke family.)

Fellow Tacoma Mountain Rescue members Ron Servine and Rick Belcher brainstormed a name for the rock while flipping through a dictionary for mountain words. It occurred to them that "spire" worked for Spanaway Park Ice and Rock Education. Volunteers completed SPIRE Rock, located between Bresemann Forest and Sprinker's sports fields, in 1976. Not just a pile of rocks, SPIRE's clever design includes every type of climbing challenge, from chimneys to buttresses. (Wayne Cooke family.)

In 2000, the Altrusa organization won a $275,000 state-matching grant to build a skateboard park. Pierce County Parks donated the land and $125,000. Skaters of all ages helped design the steel and concrete structure. In October 2005, the primary matching fund benefactor, Nancy LeMay, dedicated the Harold LeMay Skateboard Park at Sprinker Field in Spanaway in Harold LeMay's memory.

In 1996, Pierce County Parks added Fantasy Lights to Spanaway Park as a fundraiser, despite the futile objections of Spanaway residents. From November to mid-January, the park and lake access are closed to any use other than the display. The animated holiday light display, with more than 300 scenes made with thousands of lights, has become another regional treasure.

Eight

ERA OF CHANGE

In Spanaway, the last half of the 19th century was a time of rapid growth, turbulent times, and business "churn"—startups that quickly came and went. Unincorporated Spanaway was at the mercy of distant governance. In March 1946, the headline "Bigger, Better Spanaway" rang from the front page of the *Prairie Pointer* newspaper. That year, Spanaway's American Legion post wanted street signs, streetlights, water and sewer systems, traffic speed limits, and paid firefighters for the volunteer fire department. It accomplished a bit of each. In September 1947, the *Prairie Pointer* announced that the Spanaway Progressive Community Club "for the betterment of Spanaway" was organized. The torch passed to the Spanaway Community Action Network (Spanaway CAN) in 1994. The Spanaway Loop Safety Association secured a multi-lane Spanaway Loop Extension to take hurtling traffic off residential streets in 2004. The Gateway Cityhood Committee's 1999 plan to incorporate for local control failed; citizens feared increased taxes. The *Celebrate!*Spanaway Committee formed in 1999 to resolve drug, crime, and economic issues. The 7:23 Networking group has worked on "building business in greater Spanaway" since mid-2012.

Only a few family-owned businesses in Spanaway survived the turbulence to be handed from one generation to another. Sin and redemption have had the most staying power. Lake Park began with four saloons and now has five; it began with four churches and now has twelve. Redemption is winning.

Chris and Nettie Turner's homestead, about two miles due east from Spanaway Lake, became the Sky Ranch airfield. Maj. Orville French of the Tacoma Civil Air Patrol (left) shows tickets for the unit's fundraiser air show at Sky Ranch to Joe Sim, a former Air Force pilot who took part in the 1948 show. (TPL D34788-4.)

First established in the 1940s as South End Plumbing, William and Dorothy Righetti replaced their store in 1964 with the one seen in this 2013 photograph. Rex and Virginia Stead bought the store from the Righetti family in 1971. The Steads retired in 1995, and their son Brian now owns the store. South End Hardware is one of the oldest businesses remaining in Spanaway.

The Elk Plain Cafe was built in 1946 on a pie-shaped piece of land between Pacific Avenue and Twenty-second Avenue. Beginning in 1901, the property held Lillian and Thorne Tibbitts's gasoline station, grocery, and the furnished cottages of Tibbitts Tourist Camp. The popular Elk Plain Café had a series of owners before it closed in 2000. (Marianne Lincoln.)

In this 1953 photograph taken for an International Harvester advertisement, an unidentified man fills the fuel tank of a logging truck with propane. Propane was first promoted as a truck fuel in the 1950s. The sign on the logging truck door identifies the owners as "Cotten Brothers, Spanaway Washington." Regrowth and replanting have kept logging a major regional industry. (TPL Richards-A76054-6.)

In 1956, Dick Boness and his brother Fred built a dirt track in a cow pasture on their parent's dairy farm at the southeast corner of Rademaker (164th) and Military Road. It became the Spanaway Speedway, owned by Dick and Wanda Boness. The speedway hosted all types of motor sports, from NASCAR to demolition derbies. The track became a housing development in 2000. (Hearst Newspapers, LLC/Seattle P-I.)

Dennis Modahl inherited Modahl Auto Parts from his parents and managed it for several years. However, Modahl was a welder and mechanic in the National Guard, and his interest was heavy equipment, not cars. So, in 1977, Modal leased the auto parts business to Napa and built Spanaway Tractor next door (at the corner of 163rd Street and Pacific Avenue on land originally Simons Addition to Lake Park).

Lou Moriarty built the Little Park Restaurant in 1958. Set in a treed, grassy area on Mountain Highway and 171st Street, Moriarty said, "Spanaway Park is the big park, so this is the Little Park." Paul Dillinger bought the restaurant in 1962 and sold it to John and Charlotte Kline in 1984. Their son Lloyd now owns "the home of the Mountain Burger."

In 1957, Ralph "Slim" Lawson bought the Spanaway Aircraft Company (on 188th and Mountain Highway) that Roy Lape and Bud Moore had established in 1946. Lawson logged 14,000 hours as instructor for his Spanaflight School and was inducted into the Washington Aviation Hall of Fame in 2002. His son Wayne Lawson inherited Spanaway Airport in 2009. (Hearst Newspapers, LLC/Seattle P-I.)

Irvin Ball owned the Exchange Saloon as Irv's Exchange Tavern from the 1940s until 1973. A couple wild local boys, who owned a slaughterhouse, had a dispute with Ball and dumped a truckload of manure on the porch of the Exchange in protest. When Ball retired, he sold the Exchange (sans manure) to James "Jim" Tucker and Jack Smith, who in turn sold to Robert Pailca. (Elaine [Simpson] Ossun.)

Crystal's Flowers and Gifts opened on December 2, 1975, at the northwest corner of Thirteenth (174th) Street and Pacific Avenue (on Spanueh Station's oat field that had become part of the Robert Locke claim). Randy Prine bought the florist shop in February 1987. He had semi-retired to work as an employee when he sold it to Gail Ditmore in December 2005. Crystal's provides flowers for all occasions. (Randy Prine.)

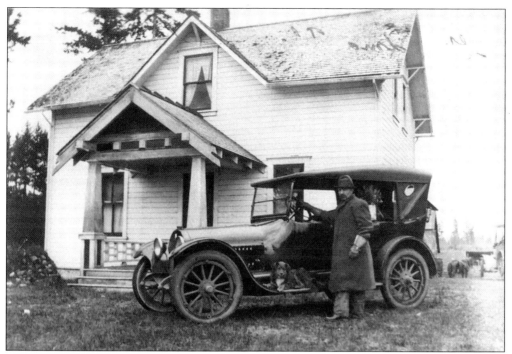

In 1920, John Landstrom visited the Overaas at their home, which was built on the 1883 John Nilson claim. Before the Overaas bought it for their turkey farm (now Fir Lane Memorial Park), the claim was held, in succession, by William Niessen, Adam Benston Jr., and L. Barlowe. The house shown here was originally a cabin. Around 1915, it was moved closer to Henry Berger Road (176th Street), where a second story was added. (SHS.)

After *Early Spanaway* by Dorothy Thompson Winston was published in 1976, interest in the book generated the Spanaway Historical Society. In 1989, Charles and Sue Overaa dedicated his family's original farmhouse and outbuildings on a 99-year lease to the historical society, thus creating the Prairie House Museum. Donations and volunteer labor restored the original farm buildings.

The Dominican Sisters decided to sell Marymount in 1989. Harold LeMay agreed on a handshake to buy Marymount to house his collection of more than 3,000 vehicles. LeMay's 1940s Spanaway Refuse Company had grown into the 10th largest in the nation and had become part of Harold LeMay Enterprises. LeMay preserved Marymount's historic buildings, which now hold the LeMay Family Collection of automobiles and Americana. (LeMay Family Collection Foundation.)

Charles Wright bought the Henry Jahns donation claim and platted it as Wright's Clover Creek Addition. In 1890, Captain Ludlow and his wife, Mary, took 80 acres for their homestead. In the 1920s, George and Amy Jensen bought the Ludlow house with 10 acres as their Silver Fox Farm. In 1998, Lynda Hogan and Anne Park renovated the farmhouse for the Gateway Cottage. Lynda Hogan is now sole proprietor.

In the early 1900s, Lake Park's four saloons were balanced by four churches: Catholic, Congregational, Lutheran, and Methodist. All of these congregations (and eight others) remain. Despite a pastor in the 1930s with "atheistic leanings" and one in the 1940s who "gave up in despair"—church history doesn't say why—the Methodist church, shown here in its third building since 1908, continues to thrive.

The Exchange Tavern survived the 1890 land purchases of the Lake Park Land, Railway, and Improvement Company, the 1893 Panic, a 1922 town fire, Prohibition and the Great Depression, a 1970s tavern extortion racket, a 1980s organized crime takeover attempt, 1990s rezoning, and a series of owners to become the only original business remaining in Spanaway today. This photograph shows Irvin "Irv" Sensel, owner of the tavern from 1985 to 2001.

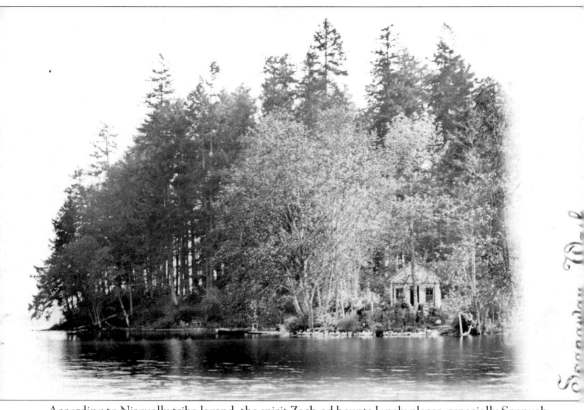

According to Nisqually tribe legend, the spirit Zach-ad haunts lonely places, especially Spanueh Lake and its swamps and woods. Zach-ad means "to cry," and the spirit is said to foretell a loved one's death. This image evokes the lake's ghostly quality. When a homesteader tried to barge a house over to Primrose Island, the house sank to the bottom of the lake to rest there with stills dumped as revenuers raided, lost souls drowned in the lake's deceptively calm waters, and cars that plummeted with their drivers into the depths (some reputedly helped by the mob). Eventually, the house was raised and plunked on dry land and joined by others on Enchanted Isle—renamed to acknowledge Zach-ad, who makes his presence known to those who intrude upon his haunted, lonely place. (Frank Witham.)

Bibliography

Anderson, Steve A. "The Forgetting of John Montgomery." *Pacific Northwest Quarterly*, Vol. 1. No. 2. Seattle, WA: University of Washington, Spring 2010.

Bonney, W.P. *History of Pierce County*. 3 vols. Chicago, IL: Pioneer Historical Publishing Company, 1927.

Dickey, George, ed. *Journal of Occurrences at Fort Nisqually: Commencing May 39, 1833, Ending September 27, 1859*. Tacoma, WA: Fort Nisqually Association, 1989.

Ficken, Robert E. *Washington Territory*. Pullman, WA: Washington State University Press, 2002.

Henderson, Alice Palmer. *The Ninety-First: The First at Camp Lewis*. Tacoma, WA: John C. Barr, 1931.

Martinson, A.D. *Wilderness Above the Sound: The Story of Mount Rainier National Park*. Niwot, CO: Roberts Rinehart, 1994.

Morgan, Murray. *Puget's Sound: A Narrative of Early Tacoma and the Southern Sound*. Seattle, WA: University of Washington Press, 1981.

Prosser, Col. William Farand. *A History of the Puget Sound Company*. Vol. 2, *Its Resources, Its Commerce, and Its People*. New York, NY: The Lewis Publishing Company, 1903.

Rhind, William, et al., ed. *Journal of Occurrences: January 1, 1860 –May 11, 1870*, Tacoma, WA: Fort Nisqually Living History Museum, 2011.

Robertson, Donald B. *Encyclopedia of Western Railroad History*. Vol. 3, *Oregon, Washington*. Nebraska: Caxton Press, 1995.

Stiles, T.L. "Spanaway Park and Flume Line Abstract." Tacoma, WA: Metropolitan Park District of Tacoma, 1925.

———. *Washington Territory Donation Land Claims*. Seattle, WA: Seattle Genealogical Society, 1980.

Wickersham, James. "Nusqually [sic] Mythology." *Overland Monthly*. July–December, 1898.

Wing, Warren. *To Tacoma by Trolley: The Puget Sound Electric Railway*. Edmonds, WA: Pacific Fast Mail, 1995.

Winston, Dorothy E. Thompson. *Early Spanaway*. Spanaway, WA: Spanaway Historical Society, 1976.

———, comp. *Army post condemnation: Camp Lewis, Pierce County, Washington: Case No. 4165 24 July 1918 and case No. 1288142, 11 October 1941*, Tacoma, WA: Tacoma-Pierce County Genealogical Society, 1998.

DISCOVER THOUSANDS OF LOCAL HISTORY BOOKS
FEATURING MILLIONS OF VINTAGE IMAGES

Arcadia Publishing, the leading local history publisher in the United States, is committed to making history accessible and meaningful through publishing books that celebrate and preserve the heritage of America's people and places.

Find more books like this at
www.arcadiapublishing.com

Search for your hometown history, your old stomping grounds, and even your favorite sports team.